MAGRITTE

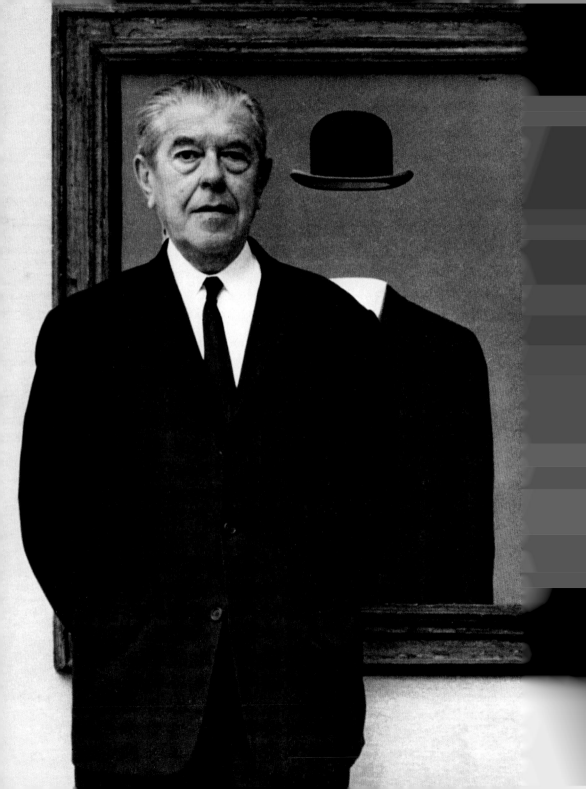

MASTERS OF ART

MAGRITTE

Alexander Adams

PRESTEL

Munich · London · New York

Front Cover: *The Man in the Bowler Hat*, 1964 (detail, see page 32)
Frontispiece: René François Ghislain Magritte, 1967, unknown photographer
pages 8/9: *Entr'acte*, 1927 (detail, see page 51)
pages 38/39: *The Empty Mask*, 1928 (detail, see page 57)

page 62: *La Géante* (The Giantess) by Paul Nougé, English translation by John Weightman
© 1993 Menil Foundation, Inc. Originally published in David Sylvester and Sarah Whitfield,
René Magritte Catalogue Raisonné, vol. 2. Reprinted by permission.

© Prestel Verlag, Munich · London · New York 2022
A member of Penguin Random House Verlagsgruppe GmbH
Neumarkter Strasse 28 · 81673 Munich

© for the reproduced works by Giorgio de Chirico and René Magritte: VG Bild-Kunst, Bonn
2022; and by Man Ray: Man Ray 2015 Trust / VG Bild-Kunst, Bonn 2022

A CIP catalogue record for this book is available from the British Library.

Editorial direction Prestel: Anja Besserer, Andrea Bartelt
Picture editing: Kerstin Pecher
Copyediting: Vanessa Magson-Mann, So to Speak
Proofreading: Sarah Trenker
Production management: Andrea Cobré
Design: Florian Frohnholzer, Sofarobotnik
Typesetting: ew print & media service gmbh
Separations: Reproline mediateam
Printing and binding: Litotipografia Alcione, Lavis
Typeface: Cera Pro
Paper: 150 g Profisilkk

Penguin Random House Verlagsgruppe FSC® N001967

Printed in Italy

ISBN 978-3-7913-8794-9

www.prestel.com

CONTENTS

6 Introduction

8 Life

38 Works

110 Further Reading

INTRODUCTION

When the word "Surrealism" is spoken with regard to art, two names spring to mind: Salvador Dalí and René Magritte. For both names we can recall masterworks and favourite pictures. We remember Dalí's distinctive moustache, his eye-popping leer and perhaps his heavy Catalan accent. And as for Magritte...? Even those familiar with his art will have trouble finding an adjective to describe the man (rather than his conventional appearance), let alone be able to recount any anecdote involving him. His habitual attire of suit, tie and bowler hat were anonymising, rendering him invisible. Absence of widespread familiarity with Belgian culture has served to make him even more indistinct.
This would not, one suspects, entirely have displeased Magritte.

Magritte took pains to make himself an affable cipher to curious foreign photographers, interviewers and art critics who sought him out in the 1950s and 1960s, when his art was becoming world famous. He rather enjoyed being considered unremarkable, even something of a disappointment, especially in comparison to his eccentric Spanish colleague-cum-rival. Yet Magritte was once a youthful firebrand, Communist and anarchic prankster in a group famed for its subversive humour. His early art is shot through with angst and the macabre. When erotic drawings surfaced after his death – and when he was posthumously accused of engaging in forgery – this seemed at odds with the established image of Magritte-as-everyman.

In truth, Magritte subverted expectations about art, artists and the world, and did so all the more effectively by disguising himself as unremarkably bourgeois.

As we will see in this book, Magritte (despite his deferential manner and drole replies to interviewers) was proud of his art. He could be competitive and difficult. He realised that his art had broken new ground and had proved influential among his Surrealist peers (including the young Dalí and Paul Delvaux), as well as for later generations. To the Pop artists of the 1950s, the Conceptualists of the 1970s and the Neo-Expressionists of the 1980s – not to mention advertising-and-branding designers of every decade – Magritte's art has meant different things. Although he was indifferent or hostile towards later art, Magritte was not at all indifferent to the fact his art was increasingly widely seen and discussed. Even now, it appears that artists, admirers and art historians may have overlooked a core aspect of Magritte's artistic character: his profound attachment to Romanticism. This book will present that aspect and examine how it fits (and conflicts) with Surrealism.

Magritte's art is thoughtful but not cerebral, obscure or even intellectual. One understands it instinctively and emotionally, without guidance. There are no hidden keys or theoretical texts which unlock meaning. Magritte is the antithesis of the Post-Modernists who claim him as a predecessor, in that he deliberately avoided making art references that viewers needed to know and issuing impenetrable explanatory texts cluttered with jargon. To take Magritte's neutral manner of painting for unequivocal irony is an error. Magritte meant everything that he made. We should not project Post-Modernist flippancy upon an artist who genuinely believed that art should aspire to the quality of poetry and could alter perception.

As new material comes to light – including his staged photographs and home movies – and more of Magritte's writings are published, a more complicated Magritte emerges. How committed was Magritte to the Communist party? Did materialism lead the artist to compromise himself by painting variants of popular compositions? How was Magritte's outlook influenced by the Surrealist group in Brussels, his home city? None of the (provisional) answers to these questions dilute or dispel the mystery of Magritte. His art cannot be explained. It was made to startle us out of our complacency and return us to life more awake.

The most powerful experience one can have with a Magritte painting is to encounter it unprepared, on the wall of an ordinary home. This book will provide a judicious overview of the range and character of Magritte's art (with the sole omission of his drawings) whilst avoiding the repetitions that can blunt its impact and originality. Readers will become acquainted with the main figures in the painter's life, including relatives, colleagues, rivals, dealers and collectors. They will see how the artist's relationships with collectors and dealers led to the production of particular art works and how Magritte's thinking evolved over his career. Readers will discover new aspects of, and surprising facts about, an artist who has proved to be one of the most admired and influential of the last century.

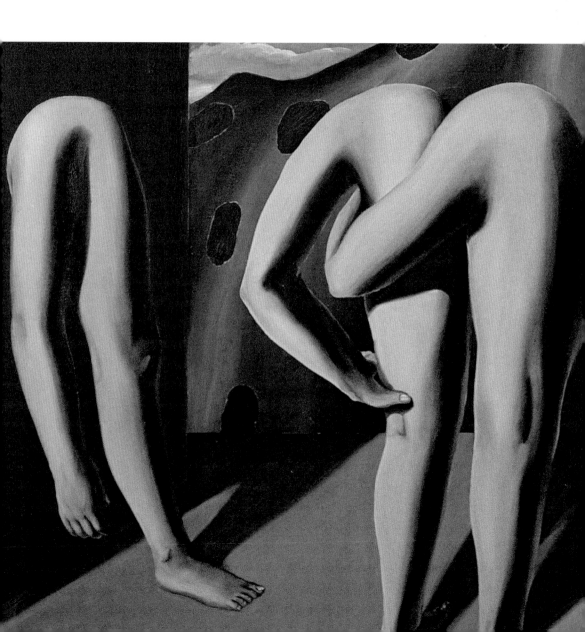

LIFE

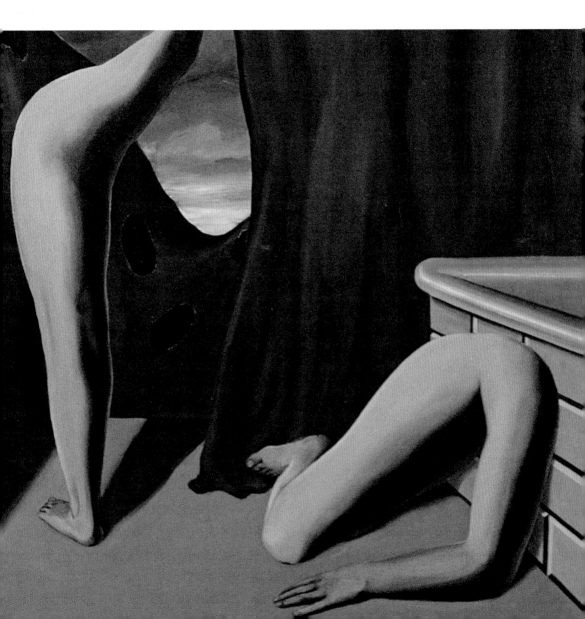

René François Ghislain Magritte was born in Lessines, Belgium on 21 November 1898. He had two brothers, Raymond (1900–1970), who became a businessman, and Paul (1902–1975), who became a composer. Their mother was Régina Bertinchamps (1871–1912); their father was Léopold Magritte (1870–1928), a factory inspector. The family lived in various addresses in the Hainaut region, which was one of the most heavily industrialised areas in the world. Heavy industry was the backbone of the Belgian economy, with steel, iron ore, coal and textiles being transported via a network of canals and railways through a polluted landscape. During the brief heyday of Imperial Belgium, the Magrittes inhabited the grimy workshop of the nation.

An early experience would prove formative. "In my childhood, I used to enjoy playing with a little girl in the old disused cemetery in a small provincial town. We visited the underground vaults, whose heavy iron door we could lift up, and we would come up into the light, where a painter from the capital was painting in a very picturesque avenue in the cemetery with its broken stone pillars strewn over the dead leaves. The art of painting then seemed to me to be vaguely magical, and the painter gifted with superior powers." In Magritte's mind, magic, revelation, mystery and erotic excitement were combined in the figure of the painter.

On 24 February 1912, Régina Magritte committed suicide (an event which is discussed on page 54). In 1913 Magritte met his future wife, Georgette Berger (1901–1986). They lost contact due to World War I, during which Belgium was defeated and occupied by German forces. Magritte attended the Académie royale des Beaux-Arts, Brussels from 1916 to 1921. Another student at this time was Paul Delvaux (1897–1994), the future Surrealist. Magritte's attendance was sporadic and the teaching was disrupted by the circumstances of the occupation. He was taught traditional academic disciplines such as drawing, painting, art history and anatomy, with supplementary classes. During his studies, he fell in with a network of young artists excited by Art Nouveau, Symbolism and Cubism. Magritte produced commercial work such as advertisements, posters and book illustrations to earn a living. For a time, he painted designs in a wallpaper factory. In 1920 Magritte and Georgette were reunited by chance in Brussels, to be married in 1922, following Magritte's year of compulsory military service.

In the early 1920s Magritte was working in a variety of current styles. These included Cubism, Cubo-Futurism, Purism, Art Deco and – for commissioned portraits and still-lifes – Realism. In 1922, he collaborated with Victor Servranckx (1897–1965) on a manifesto of Purism, that was never published. Purism was a style that combined geometric precision, clarity, subdued colour and pictorial flatness. It adulated the artificial and mechanical; common subjects were buildings and still-lifes. Late in 1923, Magritte encountered a reproduction of *The Song of Love* (1914) by Giorgio de Chirico (1888–1978). De Chirico's juxtaposition of seemingly unrelated

René Magritte and Georgette, c. 1922, unknown photographer

Giorgio de Chirico, *The Song of Love*, 1914

everyday objects in poetic yet impossible settings was termed "Metaphysical Art". The image moved Magritte to tears and transformed his understanding of what art could be.

Metaphysical Art was a key influence on Surrealism, a movement formed in 1924 from the remnants of the Dada movement. Whereas Dada had advocated anti-art, parody and political satire and was primarily reactionary and nihilistic, Surrealism would liberate art and society through the mechanisms of free association, calculated absurdity and the power of the subconscious, in order to create rather than destroy. Founder and leader of Surrealism, writer André Breton (1896–1966) studied Freudian psychoanalytic theory and believed that understanding subconscious desires and fears would fundamentally reshape human behaviour and society. Magritte wrote, "Surrealism is revolutionary because it is the restless enemy of all the bourgeois ideological values which keep the world in its present appalling condition."

In 1925 Magritte painted the Metaphysical *The Window*, his first real painting, as far as he was concerned, and found his voice with the collage *The Lost Jockey* (1926). He established his mature Surrealist style, namely painting recognisable objects in startling poetic combinations using a coolly realistic technique. Magritte's first Surrealist period (described by the artist as "cavernous") is characterised by dark tonality and a subdued palette. Subject matter is often violent, bizarre and grotesque and resembles a horror movie or gothic tale.

Surrealism explicitly allied itself to Communism, asserting that a necessary corollary of economic and political revolution was the mental liberation of people from the bonds of tradition and religion. An early periodical to which Magritte contributed was entitled *La Révolution surréaliste* (page 19); most Surrealists were members of the French Communist Party. The relationship was fractious, with Communists denouncing the Surrealists as libertines and bourgeois formalists more interested in private dreams and obscure fantasies than communicating with the proletariat. The fundamental division that was never bridged was that Communistic party orthodoxy and unwavering materialism could never have accepted the total artistic and personal freedom that Surrealists demanded. Collectivist authoritarian idealists were never reconciled to alliance with individualist libertarian idealists.

When he became aware of Surrealism, Magritte quickly absorbed the new ideas emanating from Paris. As knowledge of this new movement was disseminated, Magritte (and Georgette) became close to the circle of Brussels-based francophone Surrealist intellectuals who coalesced into a group in the late 1920s. This included writers Paul Colinet, Marcel Lecomte and E.L.T. Mesens, composer André Souris, art dealer Camille Goemans and (later) artists Raoul Ubac and Marcel Mariën (1920–1993). The unofficial leader of the Brussels Surrealists was poet Paul Nougé (1895–1967), the most committed Communist in the group. He would write a book on Magritte, published in 1943. The Magrittes were especially

close to the couple Irène Hamoir (1906–1994) and Louis Scutenaire (1905–1987), both writers. The Belgian Surrealists activities as writers, artists, collectors and dealers were fluid, forming a mutual support system, albeit one with internal rivalries and intrigues.

Some compositions which Magritte painted arose from suggestions or conversations with colleagues, as did titles. These were invented by Magritte and his colleagues after the picture was complete. They were not descriptive and were generally allusive, poetic or provocative in nature. "I think that the best title for a picture is a poetic one. In other words, a title consistent with the more or less lively emotion we feel when we look at the picture," Magritte wrote. "A title whose main function is to supply information does not require any inspiration. The poetic title has nothing to teach us, but it must surprise us and enchant us."

Magritte was concerned to have serious titles to counteract any potential dismissal of his paintings as elaborate visual jokes. Humour and playfulness were nevertheless essential factors in his thinking. He enjoyed comedy films and the manic absurdity of newspaper cartoons. The irregular holes in doors are not dissimilar to the gags in newspaper cartoon strips. Sketches of a jar labelled "horse jam" or of a couple taking a man for a walk (who is walking on all fours, wearing a dog lead) show that Magritte's irreverence entered comic territory, but that these caprices hardly ever made it beyond the drawing stage. Unlike the Dadaists and (later) the Pop artists, Magritte did not seek to provoke laughter through his paintings.

In September 1927, the Magrittes moved to Le Perreux-sur-Marne, a suburb of Paris. These were highly productive years for Magritte, who painted about fifty-five oils in 1926, seventy in 1927 and one hundred in 1928. The plan was that he would establish himself as a professional painter, assisted by Goemans, who would join the couple in Paris and open a gallery in 1929. Why Magritte did not achieve this is discussed a little later. The Magrittes never felt at home in Paris. Generally, the Belgian Surrealists had a thorny relationship with their Parisian counterparts. The Parisians considered the Belgians coarse and the Belgians viewed the Parisians as snobs. As the originators (and the most influential group in the movement), the Parisians took precedence, something that is reflected in official histories.

There were two main branches of Surrealist painting. The abstract and automatist artists sought to use chance through dripping paint or scribbling in order to free themselves of ego and uncover subconscious imagery; this group included André Masson, Joan Miró and Matta. The makers of oneiric (or dream-like) art found inspiration in impossible combinations of recognisable images, fantastic landscapes and other uncanny visions, realistically painted; this group included Dalí, Delvaux, Yves Tanguy, Hans Bellmer, Leonora Carrington and Leonor Fini. Max Ernst moved between the two branches; Francis Picabia was primarily figurative, and his abstract paintings were never automatist in character.

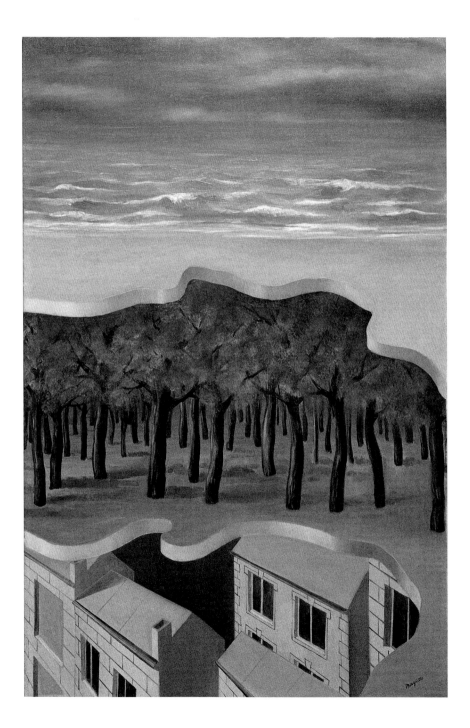

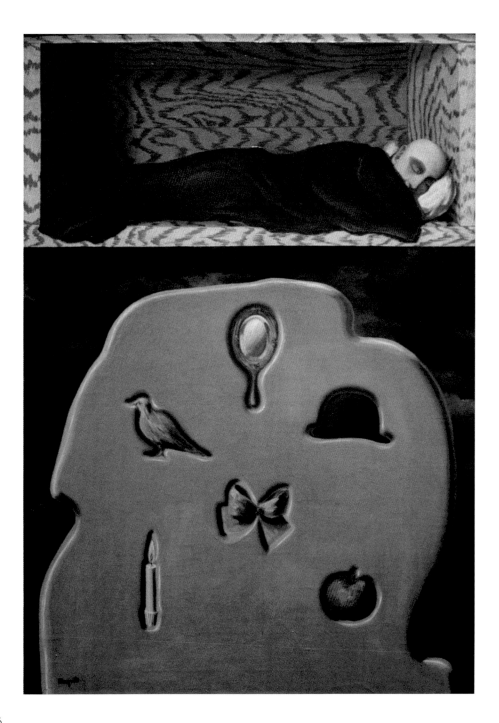

Magritte's art and temperament aligned with the oneiric tendency. He had friendly relations with many Surrealists and later acknowledged Ernst (along with de Chirico) as an influence. Magritte gave Breton a handful of paintings; Breton wrote supportively of his art, although they would have two important clashes.

In 1928, Magritte started to leave behind the dark palette and overtly macabre motifs, adopting a brighter palette, crisper drawing and less emotionally provocative imagery. Consequently, his work rate went down, with only about twenty-five canvases painted in 1929. By 1930, the transition was complete and we see Magritte's predominant mature style and repertoire of imagery. With two notable breaks (in 1943–46 and 1948), the artist would maintain this approach, periodically taking up particular motifs for short periods.

It is possible that a holiday in the fishing village of Cadaqués, at the invitation of Dalí, may have hastened Magritte's adoption of a decisively brighter palette. The artists had met in spring 1929 and were on friendly terms. During August 1929, the Magrittes, poet Paul Éluard and his wife Gala, as well as Goemans and his girlfriend, all stayed at a house near the Dalí family home. The holiday was cordial, and Magritte produced a number of paintings, one incorporating a coastal view surmounted by clouds in the shape of familiar objects. He apparently gave Dalí's sister a small painting. (Gala had already received a gift of a 1928 Magritte painting from Éluard.) This was the famous summer when Gala left her husband to be with Dalí. Although they would stay in contact over the 1930s, and Dalí would introduce him to Edward James, Magritte would later grow distant from Dalí, regarding the Spaniard's public behaviour cynically. He considered Dalí's burning giraffes (of 1937) to be sensationalised borrowing from his burning tuba of 1934. Despite Magritte's reserved exterior, he did bear grudges and could be cutting in private. A particular target was Delvaux, whom he viewed as a rival.

Magritte was ambivalent about the label "Surrealist". He participated in Surrealist social activities and appreciated the liberating spirit of Surrealist ideas. He consented to have his art published and exhibited under that description, although he preferred to think of himself as a visual poet. Later in this book we will see where Magritte drew inspiration from the example of Surrealism. Let us here consider the distance between Magritte and the Paris Surrealists.

Magritte expressed no interest in drugs, hallucinations, seances or dreams as inspiration for art; he never practiced stream-of-consciousness drawing or writing nor used experimental image-making or materials; he was a supporter of Communism but was not highly politically engaged; he was not anti-clericalist and had no response to esoterica, foreign religion and non-European culture; he was indifferent to abstract art. Magritte refused to engage in the Surrealists' discussion about the meaning of pictures. He wrote in a letter, "Most of the time people try to destroy the images I paint through claiming to 'interpret' them."

Magritte signed manifestoes and co-operated on statements and projects, but – aside from taking a handful of ideas and allowing friends to suggest titles – he eschewed collaboration while making his art. It was only the principles of the liberated imagination and poetic responses to the world which aligned Magritte with Surrealism.

Starting in late 1927, Magritte developed art that incorporated words. Words had been used in Modernist art by the Cubists and Dadaists before Surrealism commenced; Miró had included words on canvas in 1924. In the course of his advertising practice, Magritte himself had already deployed lettering with images. What distinguishes Magritte's inclusion of words in paintings is the systematic way in which he demonstrated how viewers respond differently to an image denoting an object compared to a word denoting an object. He explored the processing of verbal signs and visual signs. This was congruent to how images of a picture within a picture can make us aware of distinctions that we automatically make when sorting sensory data. These paintings set a precedent that Post-Modernist artists using language (such as Ed Ruscha, Lawrence Weiner, Barbara Kruger and Jenny Holzer) took up with alacrity.

On 14 December 1929, the Magrittes attended a gathering at the apartment of Breton, during which the host admonished Georgette for wearing her mother's crucifix. The couple departed immediately. This incident led to an estrangement between Magritte and the Paris Surrealists. In April 1930, Galerie Goemans folded, in part due to the economic crash. The Magrittes returned to Brussels permanently in July 1930. The departure from Paris in 1930 proved a break in Magritte's output as well as his life. His production rate reduced dramatically (only about ten paintings were made in 1930) due to spending more time on finish and details and because he had to resume commercial design work, operating from home. The Great Depression reduced the demand for art.

From the late 1910s to the 1950s, Magritte made commercial art, most actively in the 1920s and early 1930s. The work included book illustrations, sheet-music covers, posters and advertisements. Promoted products were confectionary, perfumes, cigarettes, as well as theatre and musical performances. The designs were Modernist – even Surrealist – in character. The most creative pieces were illustrations for Brussels fashion houses, which utilise collage and photographic montage. These designs showed resourcefulness and creativity, but their maker never considered this material to be art. As early as 1922, Magritte resented the shackles of such activity. "APPLIED ART KILLS PURE ART [...] Many artists spend the better part of their lives destroying themselves manufacturing artefacts that sell in mass production."

Back in the fold of his colleagues in Brussels, Magritte resumed his previous life, albeit under unfavourable economic conditions. The 1930s were a period when the artist photographed himself and friends acting out absurd, comic, mysterious and sinister performances. These resemble stills from silent films. Sometimes he

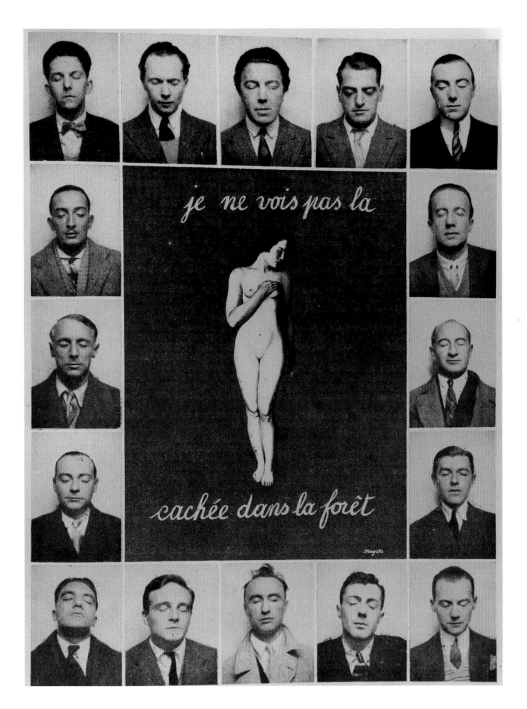

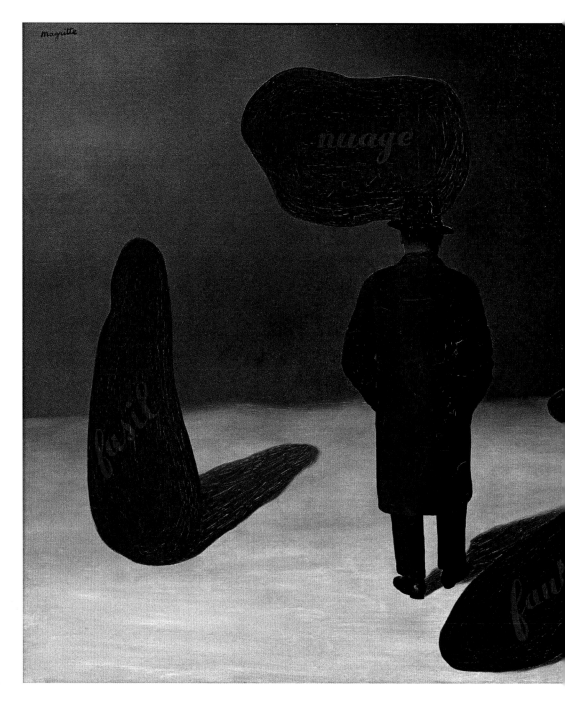

The Apparition, 1928

The False Mirror, 1929

Annunciation, 1930

24

recreated tableaux from his paintings. Later, Magritte would acquire a home movie camera and shoot amateur films. In recent years, these photographs and films have been studied, exhibited and published, expanding our understanding of his ideas and temperament. Although Magritte used a handful of these photographs as the bases for paintings, he was content to create photographs and films for his own amusement and it is clear that he never regarded these as art.

In the 1930s, the public persona of Magritte was established. Rejecting the cult of personality and the mystique of bohemianism, Magritte and Georgette lived orderly, conventional lives in the suburbs of Brussels, with their pet dog. He dressed soberly and took the tram into the city centre to meet friends in cafés and to play in a chess club. He did not go out of his way to announce himself as an artist to strangers. Apart from flashes of anarchic humour and unconventional ideas, Magritte was indistinguishable from the middle-class population who worked in banks or offices and populated the orderly streets. He painted either in the kitchen or living room, never having a dedicated studio. This very ordinariness stood in contrast to what was expected of an artist, especially a Surrealist.

One area where Magritte did conform to artistic norms was in his support for Communism. Like the majority of Belgian and French intellectuals of the era, he agreed with the need for social revolution. However, one can better see this allegiance as an expression of antipathy towards Fascism rather than a commitment to the dictatorship of the proletariat. Magritte made anti-Nazi statements in a 1938 speech, wrote occasionally for Communist publications and made some trade-union posters. However, apart from a feeling of solidarity with the working class, wanting to see artists increase their income and a desire to oppose Fascism, Magritte cannot be considered ideologically orthodox. His priority was freedom of expression, which put him at odds with the party. "If we wish to exclude systematically this luxury [intellectually free art] from the Socialist world, we are consenting to an offensive, sordid mediocrity, at least in the intellectual domain. A superior life cannot be conceived of without genuine luxury."

The invasion of Belgium and France by Nazi Germany in the summer of 1940 was a disaster for these countries, but especially for certain groups. One of these groups comprised of artists and intellectuals who had voiced opposition to Fascism. The Surrealists fled for southern France, Great Britain and across the Pyrenees to Spain and Portugal, seeking passage to the USA. In May, Magritte escaped to Carcassonne in Southern France, travelling with Scutenaire, Hamoir and Raoul and Agui Ubac. He returned to Brussels in August, after the surrender of France and Belgium, considering himself relatively safe. (Fellow Surrealists, Ernst and Bellmer – both German citizens – were for a time interned as enemy aliens by the French.) Georgette had not accompanied her husband due to marital tension. However, on his return they were reconciled and remained married until Magritte's death.

Notwithstanding shortages and oppressive circumstances, the Magrittes were not in special danger in Brussels. As an act of Surrealist resistance, Magritte rejected both the harsh realities of the Occupation and his former disturbing imagery. Starting in 1943, he adopted the colourful palette and flickering brushwork of Renoir for scenes of fantasy. Despite the intention of bringing pleasure to viewers, the artist could not resist including unsettling images: a merman hanging from a gibbet, a man whose head is that of a pig, or a pear-headed conjurer. In general, Magritte's Renoir-period subjects are more whimsical than usual.

Mariën claimed (in his 1983 autobiography) that during the war, Magritte had made fake Picassos, Braques, Klees and de Chiricos as a means of raising money. Georgette contested the assertion in court, but experts tend to believe Mariën was telling the truth. A number of Magritte's forgeries have been located and published. Mariën was a trusted confidant and associate of Magritte until his impudence and indiscretions caused Magritte to split from him in 1954. As the war was ending, Magritte made illustrations for a number of books, including the classic proto-Surrealist *Les Chants des Maldoror*. Magritte – as many intellectuals did – joined the Communist Party in 1945, mainly as a means of expressing appreciation for the work of wartime resistance groups and encouraging social reform. The affiliation lapsed within two years, demonstrating his lack of enthusiasm and unwillingness to suborn freedom to the necessity of political conformity.

Following the end of the Occupation, Magritte restored his links to Paris. In 1946, he visited Picabia and Breton there. The former was receptive to the Renoiresque paintings, but Breton was completely against them. As a whole, the new style was not well received. It seems that the tonal incongruency between subject material and execution left viewers baffled and made it difficult for even sympathetic viewers to take the work seriously. Without too much protest, the artist returned to his usual approach. In 1948, Magritte sabotaged his first solo exhibition in Paris. He made a group of pictures in a unique style that was so unexpected, crude and ridiculous that even the Surrealists were nonplussed. This so-called "Vache period" lasted only five weeks (page 84). For the remaining two decades of his life, Magritte would make art in his standard approach.

What was Magritte's standard approach? Here is a list of the pictorial means by which Magritte aimed to make us reconsider our assumptions about the world. Unexpected juxtaposition (a bird in front of a man's face, *The Man in the Bowler Hat*, page 32); change of scale (a giant apple, *The Listening Room*, page 95); metamorphosis (woman turning into sky, *Black Magic*, page 81); transformation of properties of an object (rock defying gravity, *Castle in The Pyrenees*, page 97); transformation of material of objects (objects turned to stone, *Memory of a Voyage*, page 93); combination of materials or objects (the fusion of carrots and bottles, *The Explanation*, page 89); convergence of different

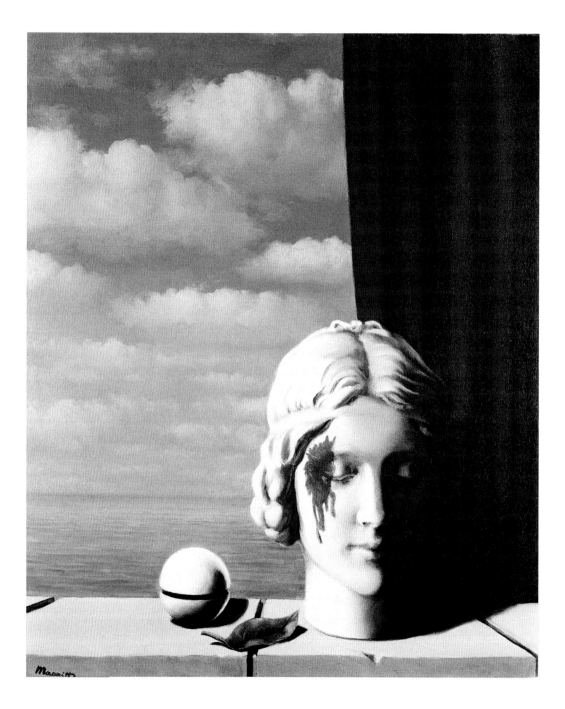

28

Memory, 1948

types of depicted reality (a painting of a mountain being indistinguishable from a view of that mountain, *The Call of the Peaks*, page 79); analogy between similar but different types of object (a torso replacing a face, *The Rape*, page 27); replacement of an object with an associated object (an egg substituting for a bird, *Elective Affinities*, page 65); distortion of space (men and trees shuffled, *Mother Goose*, pages 36–37); distortion of optics (the mirror that refuses to reflect faithfully, *Not to Be Reproduced*, page 69). Additionally, there are objects of indeterminate nature, especially in the early years (the lead-like plaque, *The Intemperate Sleeper*, page 16); fantastical entities (limb-beings, *Entr'acte*, page 51). Pictures involving language (*The Apparition*, pages 20–21) are another category we could call "meta-pictorial". Magritte came to understand these approaches in the mid-1930s, years after he had begun to explore them intuitively. A final category only emerged post-war: images which are not impossible or incredible but have a powerful quality of beauty or strangeness (*Towards Pleasure*, page 105).

There is no Magrittean formula. Magritte reflected at length about which daydreams would transcend caprice and attain the quality of inspired thought. As he grew older, he dropped lurid imagery and depicted nature more accurately, harnessing our responses to pleasure. This is why Magritte as a pastoral Romantic artist is a viable reading for Magritte's post-war period. The nocturnal pastures, copses at dusk, houses on the edge of town, rocky coasts and expansive views of mountains are filled with air and realistic lighting. The cavernous claustrophobia of 1925–30 has been set aside. Magritte clearly enjoyed painting pictures that allowed him to mentally occupy distant places; his art invites us to join him in inhabiting these locations. One reason the paintings of de Chirico, Dalí and Magritte are so beloved is because of their portrayal of a consistent set of locales to which we are transported through a fusion of the artist's invention and our imagination.

The artist spent most of his life in Belgium, and the architecture and landscape in his art is often very faithful to his surroundings. When travelling through the suburbs of Brussels and rural Brabant, one repeatedly catches glimpses that are Magrittean. Magritte was so familiar with his environs that he did not need exact sources from reality when he was painting a house or a field. It was his confident familiarity with daily reality that made his unreal visions so persuasive.

Magritte was an avid reader, not only of Surrealist writers but of French classics. He read detective fiction and mysteries and a particular favourite was Edgar Allan Poe, translated by Charles Baudelaire, whose poetry the artist also admired. What were Magritte's tastes in art? Aside from artists named elsewhere in this book, he expressed appreciation for Jacob van Ruysdael and Lionello Balestieri, a now-forgotten Italian painter of sentimental scenes. He must have been familiar with Belgians Antoine Wiertz, Xavier Mellery, Fernand Khnopff and Léon Spilliaert. He admitted to admiring James Ensor but was

The Great Tide, 1951

reluctant to hear his art discussed in association with the rich history of Belgian Symbolism.

From 1946 onwards, gallerist Alexandre Iolas (1907–1987) represented Magritte's art in the USA, where Surrealism was synonymous with Dalí, whose high-profile personal appearances, zany behaviour and memorable art had captured Americans' imagination over the late 1930s and 1940s. Dalí's popularity opened doors to other Surrealists. Iolas's efforts ultimately provided Magritte with security and – eventually – material comfort, in addition to belated critical and popular recognition. In 1957, the New York attorney Harry Torczyner (1910–1998) met the artist and became not only a leading collector and promoter of Magritte's art but also a friend.

The owner of a casino at Knokke, a resort on the Belgian coast, commissioned Magritte to create a large mural (called *The Enchanted Domain*, 1953), which would combine numerous pre-existing inventions of Magritte on a single curving panoramic wall. The artist provided a detailed design and oversaw execution by a team of assistants in June 1953. Over the 1950s and 1960s, interest among the public and art trade regarding Magritte increased steadily. Exhibitions, books and interviews (radio, television and in print) expanded understanding of the art, though the artist remained relatively reticent regarding private matters and his outlook on life, proving a counterpoint to the flamboyant Dalí. Luc de Heusch made the short film documentary *René Magritte ou La leçon de choses* (1960). It included art, an interview with Magritte and

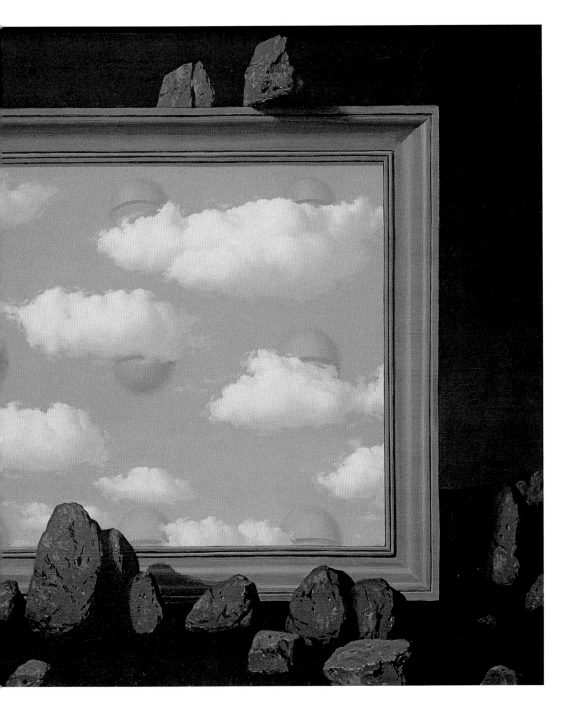

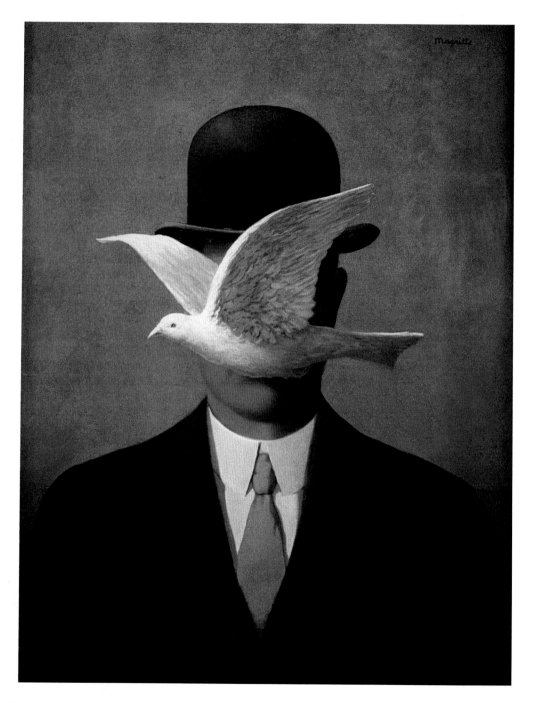

the appearance of the Belgian Surrealist group. American art writer Suzi Gablik stayed with the Magrittes for eight months, preparing a monograph on the artist.

Not all the attention was welcome. The Pop artists of the 1950s found Magritte's images of household objects to be analogous to their raising mass-produced items to the status of high art. Magritte disdained Pop. He considered these accolades a misapprehension of his purpose and wanted art to unveil the magic of the everyday world, not adulate banality nor sacralise the commercial. His career had been a flight from the deadening demands of industrial production, brand promotion and advertising methods. Discussion of Magritte as a proto-Pop artist has been so prevalent because its proponents were artists, dealers and critics with a vested interest in co-opting a great Modernist from an older generation as a figurehead of the nascent Pop movement in order to accrue legitimacy through association. If there be any doubt, consider Magritte's comments in a 1964 interview. "If we ignore the appearance nearly fifty years ago of Dadaism, then Pop art seems like a novelty. The humour of Dadaism was violent and scandalous. [...] The humour of Pop art is rather 'orthodox'. It is within the reach of any successful window decorator: to paint large American flags with a star more or less does not require any particular freedom of mind and does not present any technical difficulty."

Magritte's response to a prank is revealing. In 1962, former confrere Mariën (still a Communist) produced a photomontage including a forged banknote featuring Magritte's head. It taunted Magritte for making versions of his popular paintings for money. The police investigated this evidence of counterfeit currency and interviewed Magritte. This was all the more embarrassing as the artist was sensitive about his affluence compared to the modest incomes of the Belgian Surrealists. There were sly comments among some old-guard comrades about the grand piano he had bought for Georgette and the Italian car he had briefly owned. Magritte does not seem to have been materialistic but his previous support for Communism made his willingness to acquire the comforts due to any successful businessman left him open to superficial charges of "selling out". On the contrary, Magritte maintained his integrity and fastidiousness. The world finally rewarded his unique contribution to art. In an ironic coda, Magritte would be honoured on the final Belgian 500-franc banknote, after both he and Mariën were deceased.

In 1965 the Magrittes visited New York for his solo exhibition at the Museum of Modern Art, before travelling to Houston, where they spent time with John and Dominique de Menil, devoted collectors of Magritte's art. The Menil Foundation would fund research and publication of the Magritte *catalogue raisonné*. The couple also visited Israel, in 1966. Iolas arranged for the creation of eight bronze sculptures (in an edition of six casts each), derived from Magritte paintings. These were designed by the artist and fabricated by craftsmen at the Gibiese foundry

in Verona. Magritte visited Italy to examine the maquettes and made some alterations. At the time, no one was aware the artist had only weeks to live. Magritte painted a number of pictures in gouache specifically to be reproduced as colour lithographic prints. One was *Mother Goose* (pages 36–37), which plays with our understanding of space and sightlines. Like the bronzes, these prints were produced posthumously, indicative of how – by 1967 – Magritte's art had been accepted and was distributed to an audience made newly aware of his achievements. Thus, Magritte's career has a fittingly subversive afterlife: the creation of a small body of posthumous art.

Magritte died in his sleep of pancreatic cancer at his home on 15 August 1967. Upon Georgette's death in 1986, her collection of art was bequeathed to the Royal Museums of Fine Arts of Belgium in Brussels. In 1994, Irène Hamoir did likewise, which led to the institution coming to hold the world's largest collection of Magrittes. In 2009, this collection was made available in a museum dedicated to the artist, situated in the centre of Brussels.

David's Madame Récamier, 1967

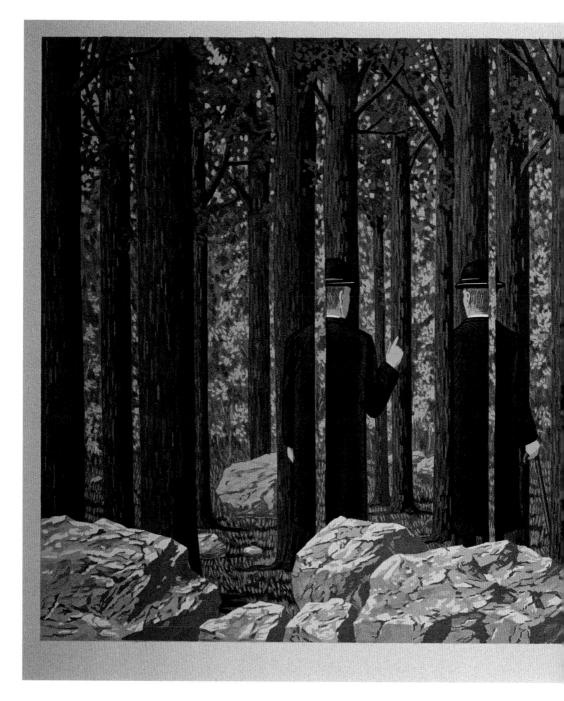

Mother Goose, 1968

WORKS

Woman on Horseback, 1922

Oil on board
63 × 90 cm
Collection Arlette Magritte

Inspired by reproductions of Futurist art, Magritte rejected Realism in 1919, near the end of his studies at the Académie. Heavy, flat geometric facets and carefully blended colour are typical of Cubo-Futurism: Cubism with some elements of movement found in Futurism. The subject of a woman riding a horse is conventional; it is the style that declares Magritte's ambition to abandon academic standards.

Magritte was later dismissive of this youthful period. "I painted a whole series of Futurist pictures in a veritable frenzy. And yet, I don't think I was a very orthodox Futurist, since the lyricism I wanted to conquer had an invariable centre unrelated to the aesthetics of Futurism. This was a pure, powerful feeling: eroticism." Magritte locates the failure of these pictures in the fact that his imperative – the erotic drive – is extrinsic to the creation of the paintings, whereas a successful Futurist painting must be constructed with greater attention to matters of composition and dynamism. A number of female nudes made in this style make apparent Magritte's conflicting drives and the unsuitability of Cubo-Futurism as a vehicle for him.

Stylistically, this painting is similar to the art of colleagues Pierre Flouquet and Victor Servranckx, who painted geometric, hard-edged forms including circles, using blended facets of strong colour. Purism was a short-lived offshoot of Cubism, which flourished from 1918 to 1925, headed by Le Corbusier and Amédée Ozenfant. (It was also followed by Dalí at this time.) In 1922, Magritte and Servranckx planned to publish a Purist manifesto, which Magritte wrote. Servranckx, who would win many official commissions and worked in the design field, remained wedded to abstraction for his mature career. Not much discussed in recent years, his distinctive art is attractive and deserves to be better known.

This picture was owned by Raymond Magritte and passed to his daughter Arlette.

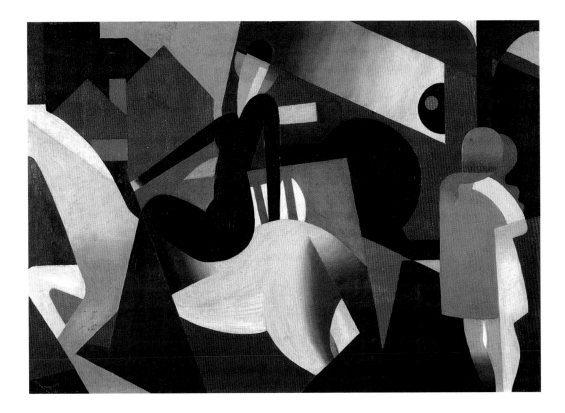

Cinéma Bleu, 1925

Oil on canvas
65 × 54 cm
Private collection, Geneva

The cool, quasi-Art Deco style of this painting is an amalgam of Purism that Magritte
enjoyed painting as an artist and the flat, stylised approach utilised on commercial
commissions for posters and sheet-music covers at this time. This hybrid style
lasted long enough for the creation of only a few pictures. *Cinéma Bleu* is a useful
touchstone for Magritte's pre-Surrealist years. The painting is an uncharacteristically
elegant and light-hearted work, but it does have touches that will recur later: spatial
ambiguity, unexplained juxtapositions, objects in flight. Hamoir reported that Cinéma
Bleu was a cinema in Charleroi when Magritte lived there.
Magritte's observable transition through phases of affinity for Realism, Impressionism,
Cubo-Futurism, Purism, Art Deco and Metaphysical Art in the space of a decade
is unsurprising. Young artists discover their interests and aptitudes through
experimentation. In Magritte's case, contact with fellow artists, attending exhibitions
and perusing art journals provided a kaleidoscopic range of Modernist art movements
to stimulate the youthful painter. Brussels was a hub of the art world, with strong
currents of influence from London and Paris. During the Occupation of World War I,
German art publications predominated. One landscape of 1919 shows influences of
Der Blaue Reiter; Neue Sachlichkeit can be detected in art made at the same time as
Cinéma Bleu. Magritte found such conversancy with a wide array of styles necessary
in the production of commercial art.
There is a danger of overemphasising the relevance of commercial practice when
assessing Magritte's art. He disdained the work and never voluntarily included it in
his exhibitions. Among his dislikes, Magritte listed "advertising". He did not raise
the subject during interviews and, when discussing it, such activity was presented
as an impediment to his aspirations as a serious artist. There was undoubtedly art
in Magritte's advertising, but we should not – with a mindset influenced by Post-
Modernism or Pop art – be too keen to conflate commercial material and fine art
when considering Magritte.

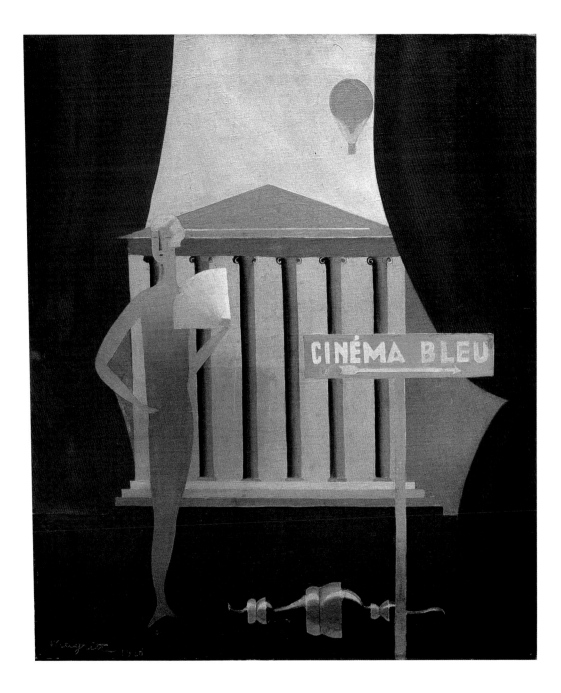

43

The Lost Jockey, 1926

Collage, watercolour, pencil, Indian ink on paper
39.3 × 54.2 cm
Private collection

From 1925 to 1927, Magritte produced around thirty to thirty-five *papiers collés* (paper collages) using sheet music, of which *The Lost Jockey* is one. Paul Magritte was a composer and Magritte designed covers for sheet music. In the era before long-playing records, sheet music and pianos were commonly found in homes. Photographic illustrations from journals were also incorporated into the collages. Another twenty-five or so *papiers collés* were made in the 1960s.

In 1925 and early 1926, Magritte struggled with his technique. We see this in his use of pencil shading on oil painting, possibly to compensate for his inadequate ability to model volume satisfactorily in paint. He experimented with collage on canvas and used house paints. He had abandoned these approaches by 1928, having gained confidence and experience.

The collages are critical and successful because they brought brightness and airiness into Magritte's otherwise stygian world. The crispness of cut outlines provides clarity. There is a playful quality to these pictures, in contrast to the ponderous leadenness of the oil paintings of 1926. As Magritte recognised, this collage was a breakthrough piece, combining hauntingly original setting and dynamic motif, enlivened by the abstract patterning of musical notation. Magritte was not able to successfully bring off this composition in oil paint at the time, although he did successfully revisit the motif in later years.

The use of original imagery and a liberating medium allowed the artist to find his voice, ending his reliance on Metaphysical Art. Later, Magritte wrote to Torczyner as much. "If one considers what I've painted since 1926, *The Lost Jockey* – 1925 [actually 1926] – for example, and all that has followed, it doesn't seem to me possible to speak of Chirico's "influence" [...] If there was an influence – which is quite possible – it's still not possible to find in *The Lost Jockey* and resemblance to Chirico's pictures." *The Lost Jockey* was apparently inspired by the artist's visits to a racecourse.

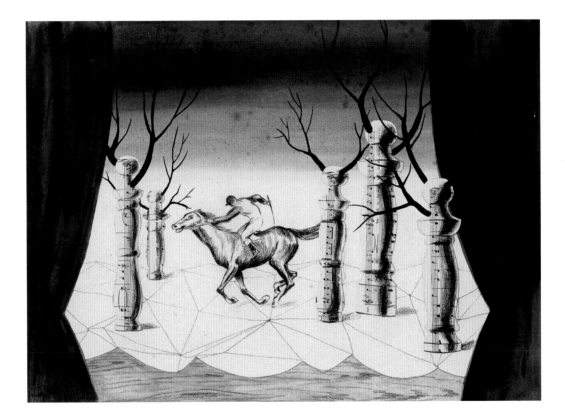

The Difficult Crossing, 1926

Oil on canvas
80 × 65 cm
Private collection

The Difficult Crossing and an associated painting called *Birth of the Idol* (1926), which were made at the same time, embody the violent, dark and anxious early maturity of Magritte during his cavernous period (1925–30). The pictures have similar pink flooring and wooden screens with apertures, which resemble stage sets. Storms recur in these paintings, with *Birth of the Idol* being set outside. Both have dismembered mannequin limbs and precariously balanced objects that generate an anxious frisson in the viewer. Even if these paintings were not made simultaneously, it is clear the artist was exploring two variations of the same pictorial idea in quick succession.

The Difficult Crossing may be related to Edgar Allan Poe's novel *The Narrative of Arthur Gordon Pym of Nantucket* (1838). That adventure story – a favourite of Magritte's – features a storm at sea, shipwreck, confinement, concealment, murder, dismemberment and cannibalism and has a pervasive air of horror. Although the painting may not have been consciously conceived as a visual retelling of Poe's story, the atmosphere of foreboding, evidence of violence and the storm echo the tone and content of the novel.

It is worth comparing Magritte's cavernous period to Paul Cézanne's early work, which is full of dark tonalities, heavy figures and scenes of violence and agitation. The two painters became regarded as cerebral painters and masters of consistency who developed variations to explore the potential of their favourite motifs. Yet their early periods are characterised by art of emotional potency and transgressive extremity, quite at odds with the common perceptions of their cautious mature output and reserved characters.

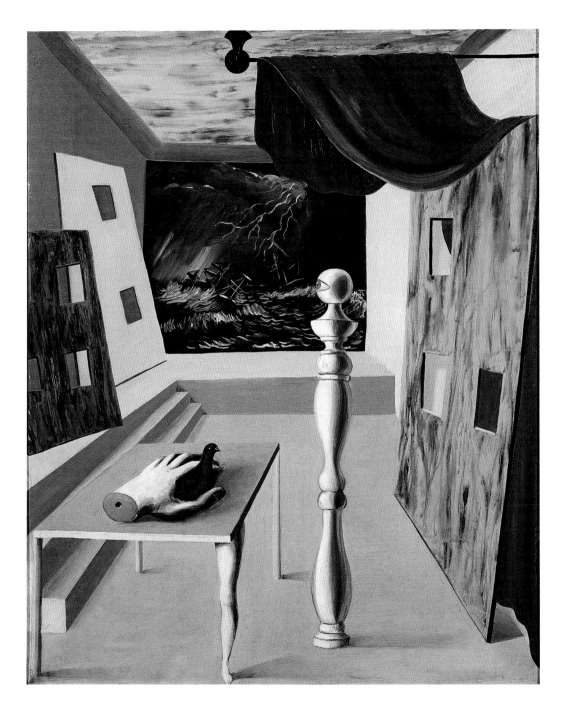

47

The Secret Player, 1927

Oil on canvas
152 × 195 cm
Royal Museums of Fine Arts of Belgium, Brussels

This scene is redolent of secret knowledge and concealed associations. In some ways, it generates the sort of wonder and apprehension that a child has upon encountering some new experience without a frame of reference. *The Secret Player* is a rare Magritte painting with characters. We could imagine the players existing in this world as people; we could concoct an explanation for the masked woman in the enclosure; a connection between them could be drawn, providing an explanation for their proximity. Ultimately, knowing Magritte's other art and his statements, we can deduce that the meaning of the painting is to prompt intrigue and reflection rather than convey a coded message. A probable reason why Magritte discontinued paintings of this sort is given on page 52.

Aside from the lost jockeys, figures in action (such as those encountered in here) become increasingly rare in Magritte's paintings after the early 1930s. In his art there is change but it is never an agent acting upon a subject. When objects float, metamorphose, decay, transfer qualities and so forth, it is inexplicable, possibly magical, and never caused by persons. We see windows, ledges, houses, towers, furniture and other manmade items but we cannot imagine the means of manufacture, acquisition or placement.

This setting is one Magritte used a number of times, starting the previous year in the first oil painting of *The Lost Jockey*, and continuing until the 1940s. The balusters sprouting branches are ersatz trees combining the artificial and natural, dead wood and living plant. Although the leafy balustrade is a repeated motif, the pink foliage is unique to this painting. The floating object is derived from a dictionary illustration of a turtle.

In early 1926 Magritte made an agreement with Galerie Le Centaure, Brussels, which stipulated that the gallery would buy his paintings, paid according to their size. Thus, *The Secret Player* and many other paintings made before July 1929 (the end of Magritte's deal with the gallery) are considerably larger than the paintings of following decades. Only in the last decade of Magritte's career, when his art was internationally recognised and there was sufficient demand, did he return to making large easel paintings. This is something of a shame, as some of the most expansive views benefit from physically immersing the viewer.

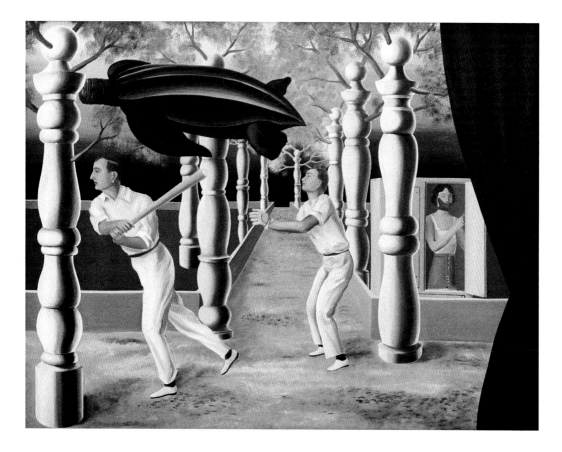

Entr'acte, 1927

Oil on canvas
114 × 162 cm
Private collection

Entr'acte is French for "intermission" (i.e. between acts), a title that seems inspired by the stage-like setting. This nightmarish vision is typical of Magritte's cavernous period. The heaviness of the limbs, alien landscape, subdued lighting and earthy coloration contribute to the oppressive air. This is one of the most successful examples of fantastical inventions by the artist. Although comparisons between Magritte and Hieronymous Bosch are infrequently persuasive, this is one of the few times when he comes close to the combinations of Bosch. The impossibility of communication with such limb-beings – no ears, eyes or mouths – makes them pitiable and alarming, yet they act and express affection and tiredness, causing us to question how we draw the line between animal and human. Perhaps the most troubling part of the painting is the indication of the potential humanity of these inhuman combinations.
What world could produce such impossibilities? The glimpse of the volcanic landscape beyond (real or a theatrical flat?) offers no reassurance. One of the transporting aspects of Magritte's art is the creation of a world that is recognisable but altered, which one could imagine inhabiting and might even want to inhabit. *Entr'acte* presents a place that is unbearably awful, even hellish. This liminal space that limb-beings inhabit is a threshold between our world and theirs.
In 1946, Magritte protested against the Surrealist strategy of disturbing and disorientating viewers, claiming he had had enough of generating horror. *Entr'acte* is one of his own contributions to this tendency.

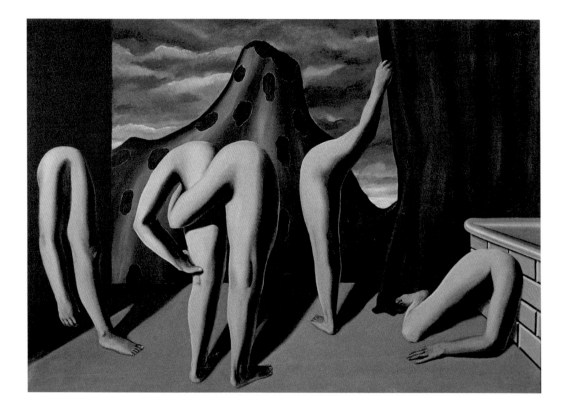

The Threatened Assassin, 1927

Oil on canvas
150.4 × 195.2 cm
Museum of Modern Art, New York

Viewing this, one of Magritte's largest paintings, in person gives one the sense of witnessing a stage play, something aided by the starkly rudimentary surroundings, reminiscent of a theatre set. The painting invites a narrative reading. The body of a woman lies on a bed; her murderer pauses to listen to a gramophone record; at the window and doorway, agents await the chance to capture the perpetrator. We await the enactment of justice, wondering if the killer will astonish us by evading the authorities. The emotional charge of crime stories comes from the audience wanting justice to be served whilst also admiring the renegade's independence and cunning, notwithstanding our condemnation of his actions. The audience's dynamic ambivalence is one principal explanation for the popularity of anti-heroes.

This painting is reminiscent of the detective stories of Nick Carter, Nat Pinkerton and the mysterious Fantômas, of whom Magritte was a fan. Fantômas was the anti-hero protagonist of a series of French stories and films. He was a criminal mastermind and sadistic sociopath who evaded capture and defied authorities' attempts to halt his transgressions. Magritte painted Fantômas, whom he apparently identified with, at least twice, writing of him: "The works of Fantômas cannot be destroyed nor suffer any modifications. [...] He moves like an automaton and shifts furniture or walls out of his way."

Magritte later eschewed painting stories. The power of art for him lay in its poetic capacity to reveal the hidden truth of the world, not in its ability to tell stories or record events. Narrative explains and distances viewers from the immediacy of experience that Magritte cherished. Adding a layer of interpretative discussion upon an image was inimical to Magritte's task of creating visual poetry.

This painting was purchased by the Museum of Modern Art immediately after its inclusion in Magritte's 1965–66 solo exhibition there.

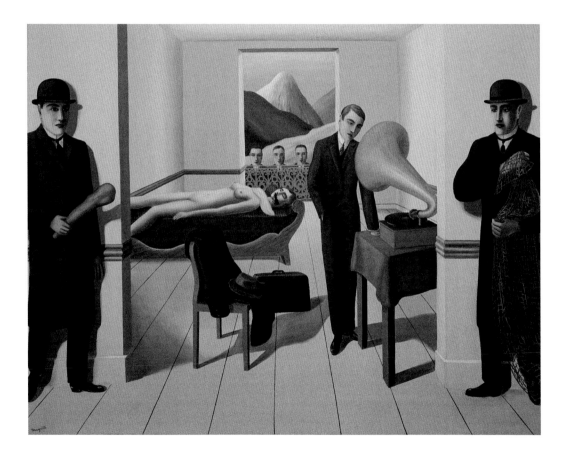

The Lovers, 1928

Oil on canvas
54 × 73 cm
Museum of Modern Art, New York

This painting of lovers robbed of their identities and separated from each other in a cruel act of enshrouding has been seen as a statement about suppressed desire, traumatic memory and political oppression. It could be viewed as a metaphor for mutual deceit, failure of intimacy or inadequacy of communication. Regardless, it is an image so powerful and unnerving that it is unforgettable. Ultimately, the power of the image imprints itself upon our consciousness without need of explanation.

In 1947 Scutenaire published the following about the death of Magritte's mother. "His mother, still then a young woman, committed suicide when he was twelve years old. She shared a room with her youngest child [Paul], who, finding himself alone in the middle of the night, woke up the rest of the family. They searched in vain all over the house; then, noticing footprints on the doorstep and on the pavement, followed them as far as the bridge over the Sambre, the local river. The painter's mother had thrown herself into the water, and when the body was recovered her face was found to be covered by her nightdress. It was never known whether she had hidden her eyes with it in order not to see the death which she had chosen, or whether the swirling currents had thus veiled her."

This text has spawned a widely known interpretation of these hooded lovers as a haunting evocation of the painter's dead mother. Why would Magritte – who refused to explain his art and disliked biographical interpretations – have approved Scutenaire's text, given that he must have known this story would provide viewers a means by which to explain paintings such as *The Lovers* in an outrightly biographical manner? This topic becomes even more confusing when we discover that the story above – which Scutenaire received directly from Magritte – is inaccurate. Régina Magritte went missing on the night of 24 February 1912, but her body was not recovered until 12 March, undercutting the implied proximity of suicide and recovery of the body. Young René (aged 13, not 12) almost certainly did not witness the recovery. A further level of ambiguity exists. Did Magritte recall the events of that night vividly but inaccurately as a false memory or was he deliberately misleading the writer? Scutenaire insisted that the gist of the story was exactly as Magritte conveyed it to him.

We will never know the truth of what Magritte saw, knew and remembered of his mother's death and how it might have affected him. *The Lovers* and the story attached to it remind us of the inadequacy of a biographical interpretation of art and the fickleness of memory.

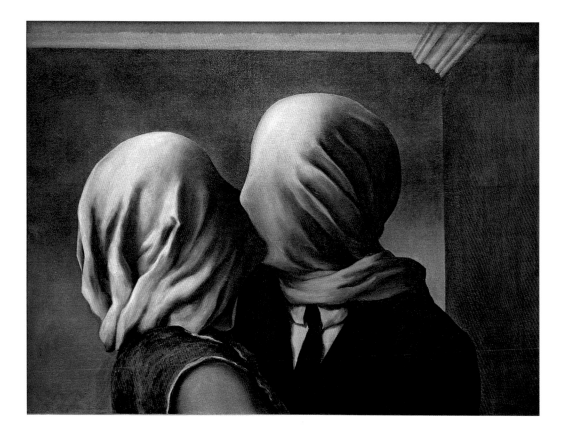

The Empty Mask, 1928

Oil on canvas
81.2 × 116.2 cm
National Museum of Wales, Cardiff

In 1928, Magritte made a conscious shift away from the cavernous period. The new paintings would display increased clarity, brighter lighting, greater stylistic refinement and attention to realism. There would be less violence and lurid imagery; human anatomies would be less wayward. Outdoor settings would replace the indeterminate environs and Magritte would paint fewer objects that defied description – such as the moulded plaques, amorphous bubbles and word balloons.
The Empty Mask is almost a manifesto for what was to be the rest of Magritte's career: recognisable forms, essential elements, careful technique, abrupt juxtapositions. A panel with inset sections holds the sky with clouds, metallic fabric with *grelots* (bells), a house façade, a pierced sheet of paper, a forest, burning coals. There is a slightly larger version of this idea in *The Six Elements* (1929), where a female torso replaces the pierced paper. *On the Threshold of Liberty* (1930) places us in a room made of such panels.
Paintings including pictures within interiors were suggested to Surrealists by de Chirico's late Metaphysical paintings from 1916–18, which include maps, diagrams and vertical flat surfaces supporting biscuits or other objects. Magritte's use of compartmentalised flat forms, especially in paintings that have plaques formed out a material akin to cast lead (page 16), greatly influenced Dalí in 1929. Dalí saw examples of Magritte's painting in person and in reproduction in the spring of 1929.
This painting was once owned by E. L. T. Mesens, the poet-collagist-gallerist who bought a large number of early Magritte paintings from a gallery liquidation sale during the Great Depression.

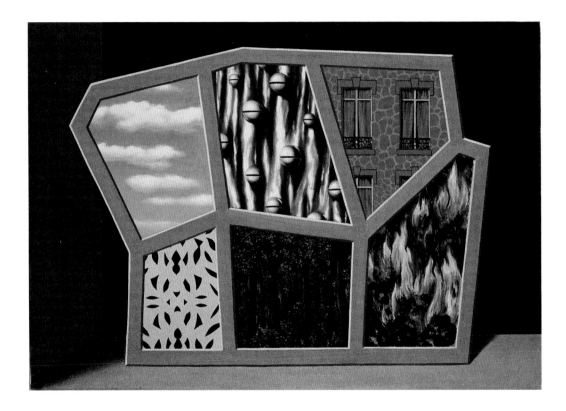

The Treachery of Images, 1929

Oil on canvas
60 × 80 cm
Los Angeles County Museum of Art

This painting, made early in 1929, has become emblematic of Magritte's undermining of conventions. *"Ceci n'est pas une pipe"* (This is not a pipe) declares the text under a realistically depicted pipe. It draws attention to the difference between reality and signs. The pipe is not a pipe; it is an image of a pipe. One cannot pick it up or smoke it; it is an image-as-pipe we call "a pipe" out of convenience and habit. Image-as-pipe and word-as-pipe are means to indicate the pipe-object, but word, image and object are all different.

The problems of how language, representation and reality interact have been central to much Continental philosophy since the early twentieth century. Ludwig Wittgenstein, Ferdinand de Saussure, Martin Heidegger and the Structuralists spent much time analysing how language shapes our understanding of reality. Michel Foucault was fascinated by Magritte's word paintings, especially *The Treachery of Images*. He had a brief correspondence with Magritte, which was cut short by the latter's death, and went on to publish a short book *Ceci n'est pas une pipe* (1968). Magritte read philosophy but never published on the subject nor claimed to have any status as a philosopher.

By the time the Los Angeles County Museum acquired this painting in 1978, it was already a touchstone for Conceptual and Post-Modernist artists using the word in art. Although use of words was a central part of some artists' practice from the 1960s onwards, Magritte used words only sparingly after the late 1920s.

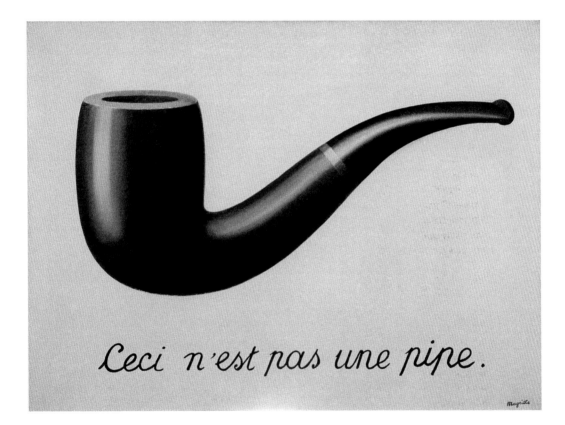

The Interpretation of Dreams, 1930

Oil on canvas
81 × 60 cm
Private collection, Vienna

In an illustrated text *Words and Images* (published in *La Révolution surréaliste*, 1929), Magritte put forth a set of propositions. "No object is so tied to its name that we cannot find another one that suits it better. [*Drawing of a leaf labelled "cannon".*] Some objects do without a name. [*Drawing of a boat on the sea with a ship on the horizon.*] An object encounters its image, an object encounters its name. The object's image and name happen to meet. [*Drawing of a forest next to the word "forest".*] [...] At times the name of an object stands in for an image. [*Drawing of two objects beside a word bubble with the word "cannon".*] A word can take the place of an object in reality. [*Drawing of a woman saying "the sun".*] An image can take the place of a word in a statement. [*The sentence "The {drawing of the sun} is hidden by the clouds".*] An object hints at other objects behind it. [*Drawing of a brick wall.*] [...] Images and words are seen differently in a picture. [*Drawing of a flower with word "mountain" superimposed.*] [...] An object never does the same job as its name or image. [*Drawing showing a horse, a picture of a horse and a man saying the word "horse".*] Sometimes written words in a picture refer to precise things, and images refer to indefinite things. [*Drawing of a word bubble with the word "cannon" next an indefinite object.*] Or else the opposite. [*Drawing of a definite object next to a word box with the word "fog".*]"
Words can be used instead of images in pictures; words can be used to undermine images (and vice versa). In this painting, Magritte gives us images and words which contradict each other. It is a sort of absurdist encyclopaedia. The egg is "the acacia"; the woman's shoe is "the moon"; the bowler hat is "snow"; the lighted candle is "the ceiling"; the glass tumbler is "the storm"; the hammer is "the desert". As we have learned from Magritte's statement (and *The Treachery of Images*), the egg is actually a painted image and the word "acacia" is a written word referring to a type of tree. Neither word nor image is truthful, both are symbols. Once we are made aware of the treachery of images and words, we are more fully conscious of how we experience the world.

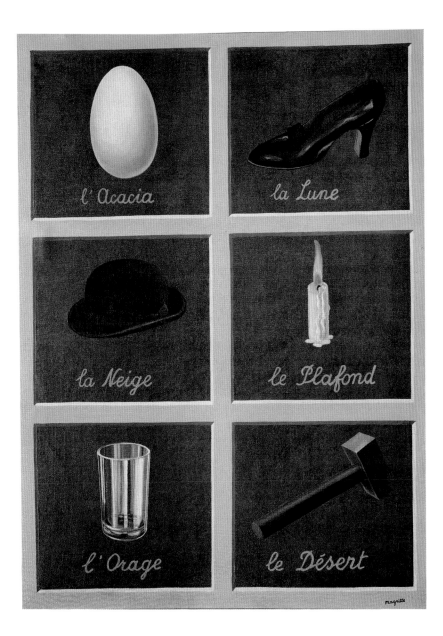

The Giantess, 1931

Oil on canvas with gouache and Chinese ink on fibreboard
54 × 73 cm
Museum Ludwig, Cologne

The poem *La Géante* (The Giantess) on the right is ascribed to the Symbolist poet
Baudelaire. It was actually written by Nougé, the first owner of the painting. Here is
the translation given in the *catalogue raisonné* entry:

Whereas a world, base but of alluring grace
Lulls with its hues the vain hope of your eyes
In the centre of my life there moves a giantess
Contemptuous, masked, and disregarding your gods

Her great body abandoned to me alone swoons
And disports itself freely in awesome games
Is appeased only to be reborn in a dark flame
Tearing the mists which float in her eyes

Forever exploring her magnificent curves
I have crawled on the slopes of her enormous knees
And sometimes, in summer, if unhealthy suns

Cause her to stretch out wearily across my dreams
I fall asleep tenderly in the shade of her breasts
With no other dream than that into which her dream plunges me.

Whether the poem was written before or after the painting was made is unknown.
Nougé was a writer of both poetry and prose, earning a living as a chemist. He was
close to Magritte until the late 1940s. The female figure in the painting resembles
Nougé's wife, Marthe Nougé née Beauvoisin.
The poem has been inscribed on a sheet of Isorel, a brand of fibreboard. The board
was affixed over the painting after completion. It is possible that the painting was
conceived of without the panel and that therefore the composition continues
underneath it. The mark in the lower part of the door is a hole, which Marthe burned
with a cigarette. No explanation for that action has been given.

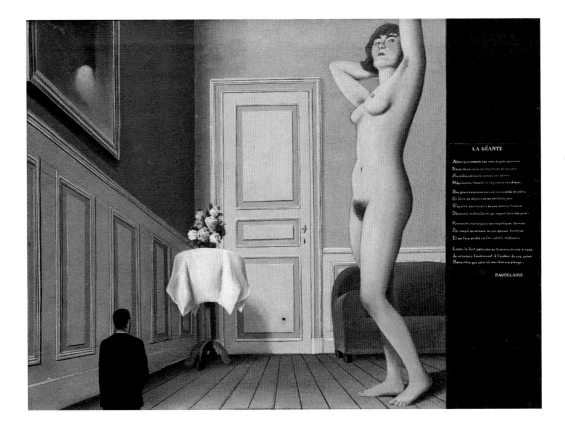

Elective Affinities, 1932

Oil on canvas
41 × 33 cm
Private collection

In a rare and revealing speech delivered in 1938, Magritte outlined the genesis of this painting. "One night in 1936 [actually 1932], I woke up in a room with a bird asleep in a cage. Due to a magnificent delusion, I saw not a bird but an egg inside the cage. Here was an amazing new poetic secret, for the shock I felt was caused precisely by an affinity between two objects, cage and egg, whereas before, this shock had been caused by bringing together two unrelated objects. From then on, I searched for other objects which could also, by bringing to light an element particular to them, reveal the same manifest poetry as the egg and the cage had succeeded in creating through their meeting. In the course of my search I became convinced that this element to be discovered, this one thing among all others somehow attached to every object, was always something I knew beforehand, but that this knowledge was as if buried down in my mind."

It was with this painting that Magritte became more analytical with his substitutions and combinations. Finding the correct substitution or alteration was akin to psychoanalytic investigation, a procedure Surrealism considered a necessary tool of self-knowledge. True Surrealism is not about bizarre illogical combinations, but combinations which illuminate hitherto imperceptible connections between images and states. In Freudian analysis, meaningful links are exposed through conversation between the analyst and patient. Magritte may have distrusted psychoanalysis, but his method of significant substitution operates in a parallel fashion to the mechanism of transferral and allusion described by Freud. In another example of meaningful substitution, *Clairvoyance* (1936) – a rare self-portrait – shows the artist studying an egg whilst painting a flying dove.

Elective Affinities was previously dated by experts to 1933, however, a newly discovered version on paper is dated 1932, so this oil version was probably created late that year. In January 1933, Magritte sent an ink-wash drawing of this design to Breton, accompanied by a letter. The title comes from Goethe's novel of 1809.

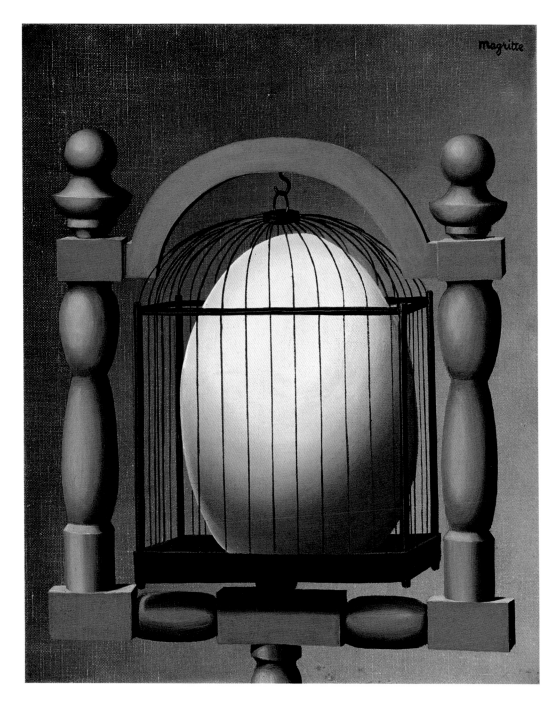

The Portrait, 1935

Oil on canvas
73 × 50 cm
Museum of Modern Art, New York

Magritte had used objects with eyes, including the finials of balusters, in his paintings since 1926. This is the most effective example of the use of an eye. *The Portrait* presents us with the shocking truth of the barbarity of all existence – that to survive, others must die, or at least be deprived, in a struggle for resources. It is the veneer of civilisation and convention that habitually obscures this truth from us. One could draw an analogy to what William S. Burroughs wrote about the naming of his novel *Naked Lunch* (1959). "The title means exactly what the words say: *naked* lunch, a frozen moment when everyone sees what is on the end of every fork." The painting seems to invite us to treat it either as confrontation or revelation; anything less than a mindful response on the part of the viewer would amount to a failure of nerve or honesty.

The eye in the slice of ham is a discomforting reminder of the way we overlook the sentience of other creatures, and even other people, when it suits us. The Surrealists intended to remove this self-serving shield from people. Yet a decade later, Magritte judged that this drive to strip away protective modes of thinking had gone too far, prompting him to make his Renoiresque pictures.

The Portrait originally belonged to Surrealist painter Yves Tanguy (1900–1955) and his second wife Kay Sage Tanguy (1898–1963), an American artist. Tanguy and Sage were great admirers of Magritte. The couple fled to the USA during World War II, staying in New York and then settling in Connecticut. Upon her death, Kay Sage left the painting to the Museum of Modern Art. (A bequest of hers was used by the museum to acquire *The Threatened Assassin*, page 53.) When questioned by the museum curators about interpretation of the title *Le Portrait*, Magritte was insistent that "The Portrait" was preferable to "Portrait".

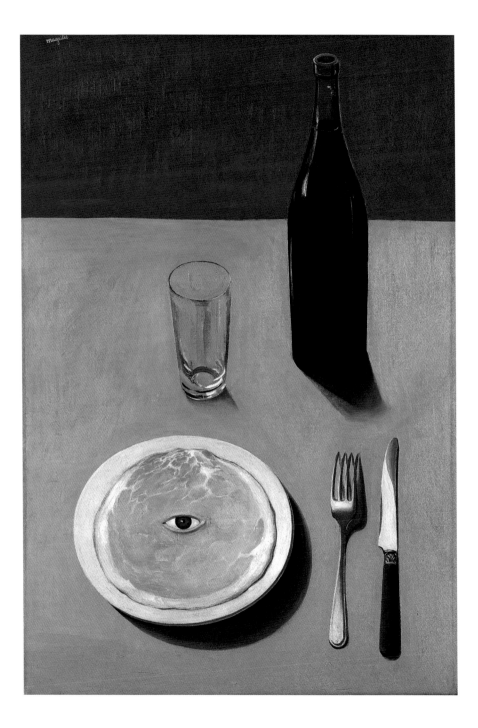

Not to Be Reproduced, 1937

Oil on canvas
81.3 × 65 cm
Museum Boijmans Van Beuningen, Rotterdam

In this painting we confront the impossible – a figure who defies the laws of optics and is thereby incapable of being reproduced faithfully. Instead of the expected reflection, the mirror presents an echo. The deadpan realism imparts a dreamlike clarity that makes it so memorable. The novel on the mantelpiece is a French translation of Poe's *The Narrative of Arthur Gordon Pym of Nantucket*.

This is a portrait of Edward James (1907–1984). Although James was a writer of prose and verse, he is best remembered as the primary British patron of Surrealism. He sponsored book publications and bought art, using his inheritance of an industrialist fortune. James claimed he was an instinctive Surrealist. "If I'm a Surrealist it's not because I got linked with the movement, it was because I was born one. A great number of people are Surrealists without having heard of the movement."

By 1939, James had amassed the best collection of Dalís anywhere, including some masterpieces; he invited Dalí to paint in London. In a similar manner, James hosted Magritte as he produced paintings to decorate the ballroom of James's London house. From 12 February to 19 March 1937 Magritte stayed in England, principally residing with James. Magritte met Henry Moore and the British Surrealists, communicating only in French.

In London, Magritte painted three large pictures: *On the Threshold of Liberty* (one of his largest paintings), *The Red Model* and *Youth Illustrated* (all 1937). *Not to Be Reproduced* and *The Pleasure Principle* (two indirect portraits of James; both 1937) were executed by the painter soon after he had returned to Brussels. As guides, Magritte used photographs of James taken during his stay.

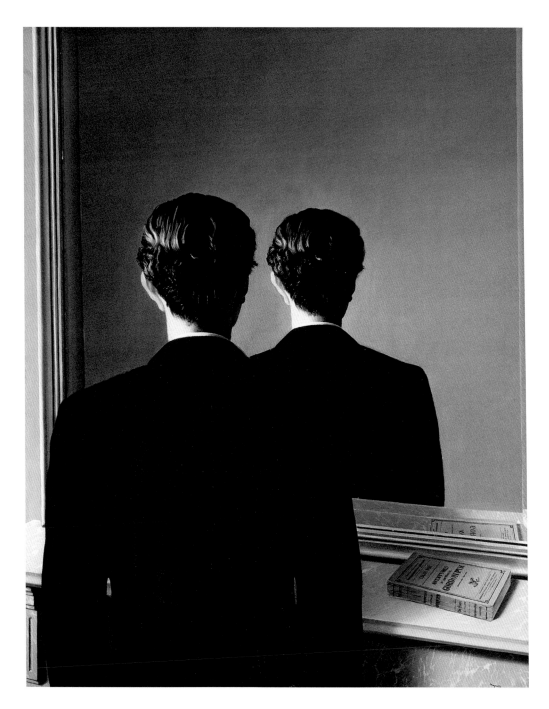

The Future of Statues, 1937

Oil on plaster
33 × 16.5 × 20 cm
Tate, London

For the base of this sculpture, Magritte used a commercially produced plaster cast popularly supposed to be the death mask of Napoleon Bonaparte. This cast, and others that Magritte altered, came from the art shop of Léontine Hoyez-Berger, Georgette's sister. It can be seen as an adapted readymade. The readymade was an idea originated by the Dadaists; it involved the appropriation of a found everyday object and changing its status from art to non-art through designation and (sometimes) light modification. Another example is Dalí's *Lobster Telephone* (1936), once owned by Edward James, whose collection also included *The Future of Statues*. Magritte gave *The Future of Statues* to James during his stay at James's house in 1937.

Throughout his career, Magritte produced painted objects and sculptures. It was not a central part of his practice nor – aside from *The Future of Statues* – were the resultant pieces well known. Other objects included painted plaster heads, statuettes and wine bottles. Some plaster casts of female heads found in versions of *Memory* (page 28) were painted with blood splashes on the temple. The wine bottles were covered with paintings of landscape or sky. A playful elaboration of *The Treachery of Images* (page 59) was a *trompe l'oeil* painting of a slice of Camembert, framed and placed inside a glass cloche for cheese; the assemblage was titled *This is not a Piece of Cheese* (two versions, both 1936).

The bronze sculptures of 1967 were the logical extension of Magritte's questioning of the boundaries between objects and images, reality and artifice. There was some discussion of Magritte (or assistants) painting the bronzes, something that was forestalled by the artist's death.

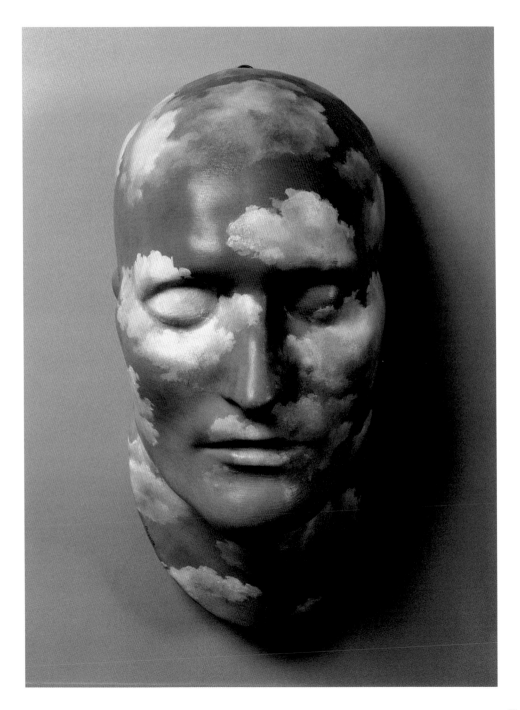

Time Transfixed, 1938

Oil on canvas
147 × 99 cm
The Art Institute of Chicago

There is an association in function between the smoke funnel of a train and the
fireplace chimney of a house. The logical analogy is impressed on us by the élan
of this composition: dramatic, precise, concise. It has the uncanniness of being
simultaneously astonishing yet peculiarly logical. In his Metaphysical period, de
Chirico (whose father worked for the railways) painted trains. Magritte rarely did
so and generally avoided references to anything overtly modern in his pictures.
The depicted train is a rare exception, being a British Stanier Class 5 locomotive,
a contemporary piece of technology. When he painted a car in 1960, Magritte
selected a model at least thirty years out of date. Almost invariably, Magritte's
aesthetic choices are Edwardian or pre-Edwardian. Clothes, technology, furnishings
and architecture all conform to the world as it was in the artist's childhood. There is
a case to be put that Magritte's art was a refutation of the modern world and what
we encounter in his timeless pictures is time transfixed.
Time Transfixed has elicited psychoanalytic commentary. The train jutting out
towards us, emitting a stream of white smoke, is judged a phallic symbol; the
fireplace is a classic feminine symbol. Such verbal rationalisation was common
among Surrealists, yet Magritte never accepted its validity. "To equate my painting
with symbolism, conscious or unconscious, is to ignore its true nature. [...] People
who look for symbolic meanings fail to grasp the inherent poetry and mystery of
the image. No doubt they sense this mystery, but they wish to get rid of it. They
are afraid. By asking 'what does this mean?' they express a wish that everything be
understandable."
Edward James bought the painting when it was exhibited in Brussels in 1939.
According to Sylvester and Whitfield, Magritte, when he stayed in London, likely
took a fireplace at James's London house as the model for this image. Magritte
advised James to hang the painting at the bottom of the curving staircase. Part
of James's collection was sold to defray the cost of building his Surrealist home in
Mexico, with the remains of the collection dispersed after his death.

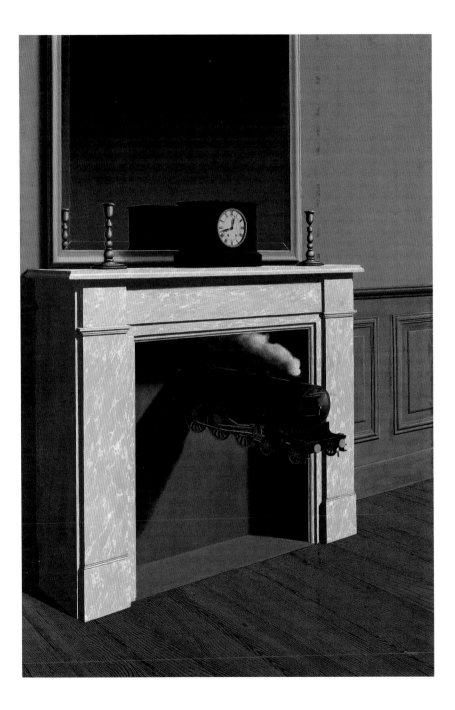

Fortune Telling, 1938 or 1939

Gouache on paper
36 × 41.5 cm
Private collection

This painting, which was once owned by Edward James, is a classic Magrittean composition, using the motif of the cloud and the domestic room, with a view of the sea. The door is partly sky. The flatness of the cloud, which has been permitted to enter the room through the narrow gap between door and door frame, seems like an insinuation. The painting was incorrectly called *Poison* for a time and one can see why the implication of cunning or deceit might have seemed fitting for this picture.

Throughout his career, Magritte painted in gouache. The *catalogue raisonné* documents over 500 gouaches, compared to over 1,000 oil paintings. Gouache is opaque watercolour paint used on paper; it was commonly used to produce commercial art for reproduction because of its flat matte surface and quick drying time. Magritte's working method was to draw small sketches, playing with images until he found a satisfactory solution to a problem that he had set himself. To make a detailed rendering, he would find suitable sources in printed form, study objects from life or rely on his imagination. Photographs were sometimes taken as guides, with friends posing. The composition then went to painted form, either in oil or gouache, with designs being transferred from drawings via the squaring method or done freehand.

In 1956 Barnet Hodes, a Chicago lawyer, commissioned the first of nearly sixty gouaches and *papiers collés* from the artist. This collection formed a miniature museum of Magritte's masterpieces, each painted by the artist to order over the last decade of his life. Magritte had mixed feelings about creating variants of existing works, something he did frequently at the behest of Iolas or collectors. He was frustrated at being reduced to mere reproduction. However, he appreciated the esteem and income, having not forgotten the lean years of the 1920s and 1930s, when he had had to rely on applied art for a living. In the later variants – one could not describe them as strict copies – there is no indication that Magritte skimped on attention or quality, as the later versions are not inferior to the originals. He sometimes changed details, either to improve the image or keep himself interested.

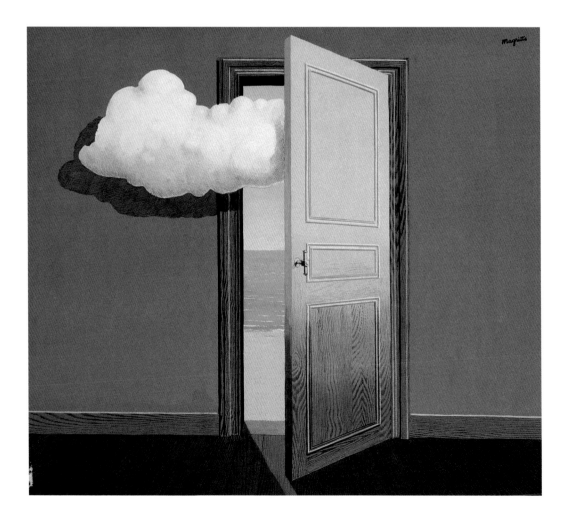

The Marches of Summer, 1938 or 1939

Oil on canvas
60 × 73 cm
Centre Pompidou, Musée national d'art moderne, Paris

This painting presents us with one of Magritte's most astonishing conceits: the sky as a solid material, capable of being stacked and rearranged like a child's building blocks. It is an expression of Magritte's huge capacity for imagination and makes us wonder at what mighty forces could be greater than nature. Reconsidering the vastness of sky as material that is limitable and subject to manipulation undermines common conceptions of the world.

Like the earth, the female torso in the foreground is sectioned. For the female body, there seems an additional division of type: the upper part is flesh, the lower part is stone. The torso presents two variants from the same source, neither is real. After all, both are parts of a painted picture. During the early and mid-1930s, Magritte took plaster statuettes of Venus de Milo and painted them to look lifelike. This act of turning a plaster replica of an ancient statue into apparent flesh was an act of subversion but it had an unintended truth to it. Only in the late twentieth century did it become widely known that the ancients practised polychromy on statues. The statues we see as pure white marble were originally painted in realistic colours. Thus, Magritte's painted statuettes and poetic reimagining of women-as-statues and statues-as-women reflect newly revealed historical facts.

Magritte declared that he preferred a beautiful woman to a beautiful statue and preferred a beautiful statue to a beautiful woman, indicating a certain mischievous dissatisfaction with any choice offered. The artist preferred the unattainable to the attainable and had a penchant for the absent intangible over the present tangible. *The Marches of Summer* is a meditation on the power of art to overcome reality, whilst at the same time admitting the inherent deceptiveness of art.

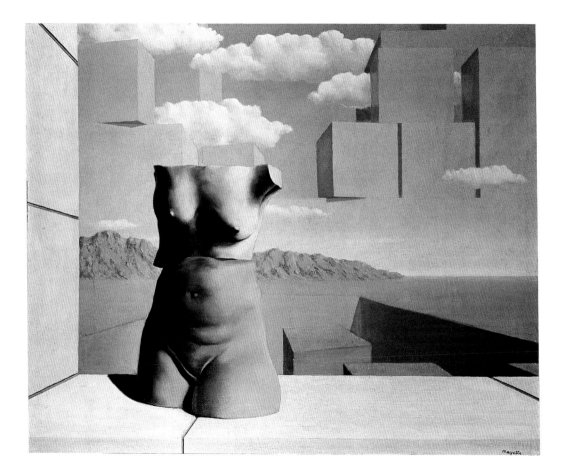

The Call of the Peaks, 1943

Oil on canvas
65 × 54 cm
Private collection

This composition combines two of Magritte's enduring motifs. The first is the picture-within-a-picture device, familiar from versions of *The Human Condition* (1933); the second is the mountain-ridge-as-bird invention, also found in *The Domain of Arnhem* (1963). The view here is more dramatic than that found in the versions of *The Human Condition* (namely a field and a beach).

The picture-within-a-picture duplicating the view it conceals is a conceit that highlights how an artist can manipulate our understanding of depicted space. Is there any qualitative difference between the picture-as-mountain and the unimpeded view of the mountain? Magritte suggests not, by making the picture-as-mountain match the surrounding view perfectly. Yet our conceptual understanding of the space tells us that if we could shift our point of view even a little, the painted image on the easel should move out of alignment.

Throughout the 1930s, European newspapers had carried stories of the climbing attempts on Mount Eiger, with many photographs published. The first successful ascent of the formidable north face was in 1938, year of the first version of *The Domain of Arnhem*. This painted mountain seems stark, picturesque and remote from human endeavour. The steep slope is implacable and resembles the dramatic paintings of the Romantics, including Caspar David Friedrich. It is a view which often recurs in the artist's last years.

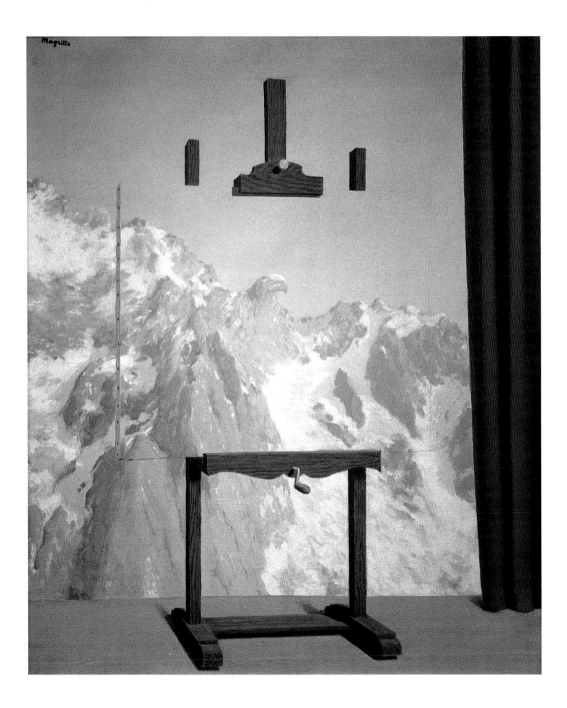

Black Magic, 1945

Oil on canvas
80 × 60 cm
Royal Museums of Fine Arts of Belgium, Brussels

"Transforming a woman's flesh into sky is an act of black magic," the painter
wrote. A figure resembling the artist's wife is transformed into sky before a sunlit
sea, confirming eternal woman as a constant in Magritte's universe. The woman is
unattainable and perfect, a force of nature. The painter arranged the clouds so that
they would frame and isolate the blue head from the blue sky. The imposing vertical
of the wall to the left frames and reinforces the vertical axis of the composition.
Over the years, as Georgette grew older and became tired of modelling, Magritte
worked with other models. Agui Ubac and Marthe Nougé apparently acted as
such and reportedly, there were others. Magritte tended not to paint from life
much (and certainly not outdoors after his early, pre-Surrealist years), so it is likely
he used drawings, art by other artists and photographs as sources – in addition to
his imagination. The women in Magritte's paintings aspire towards the ideal form
of Georgette. Being representations of universal constants and undifferentiated
types, they are passive or undemonstrative. An exception would be the woman
on all fours in The Invention of Fire (1946).
Magritte provided ink drawings to illustrate Comte de Lautréamont's Les Chants
de Maldoror (executed 1946, published 1948). Sexually explicit illustrations for
Georges Bataille's Mme Edwarda (executed 1946) were not published until
after the artist's death. These were unsigned and planned to be published
clandestinely, but never were. It is easy to overlook the erotic impulse behind
some of Magritte's art. While it has been commonplace for writers to apply
sexual readings to Picasso's art, Magritte's art is less autobiographical and the
Belgian was much more reticent about his private life.

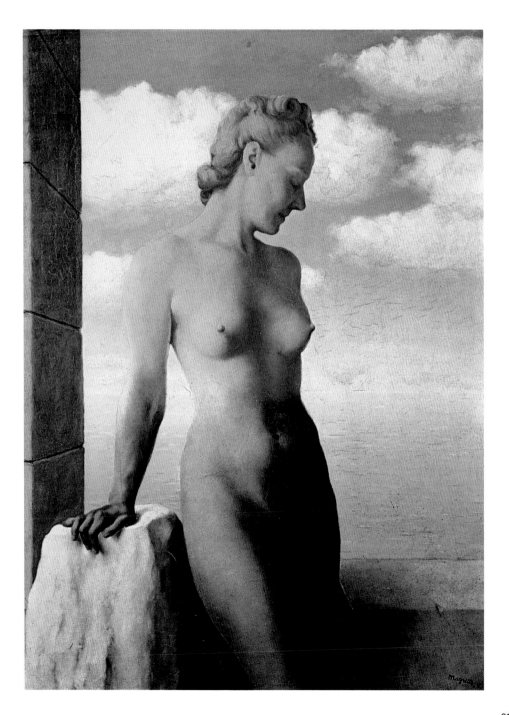

The Age of Pleasure, 1946

Oil on canvas
80 × 60 cm
Private collection

In April 1943, as a direct attempt to escape the oppressive atmosphere of life in German-occupied Belgium, Magritte took up the palette and style of Renoir. He retained many of the motifs and subjects of his usual Surrealism. "We had this experience [of disorientation and discomfort] during the Occupation and it wasn't funny. The confusion and panic that Surrealism wanted to create in order to bring everything into question were achieved much better by the Nazi idiots than by us, and there was no question of avoiding the consequences." Magritte wanted to do the reverse. "In opposition to the general pessimism I set the search for joy, for pleasure. I feel it lies with us, who have some notion of *how feelings are invented*, to make joy and pleasure, which are so ordinary and beyond our reach, accessible to all."

In paintings such as *The Age of Pleasure*, there is an increased emphasis on imagery that is sensual and erotic. The combination of style and subject is troublesome. Magritte's compositions succeed because of clarity and neutrality. Through the lashings of Renoiresque brushwork, one struggles to discern motifs and spatial values. The resultant ambiguity is dissatisfying in most of the paintings in this style, which lasted until spring 1947.

Magritte attempted to form an artistic movement based on this style, issuing a manifesto called *Le Surréalisme en plein soleil* (Surrealism in Sunlight) in 1946. While Picabia gave his backing to Magritte's Surrealist-Impressionist paintings, Breton definitely did not. After the painter had made his case, Breton replied: "Let me assure you that none of your latest canvases gives me any impression of the sun (of Renoir, yes): really, not the slightest illusion." Breton then went on to raise the subject of how far de Chirico had fallen, in the eyes of Surrealists, in his pursuit of beauty.

Magritte's sunlit Surrealism was too idiosyncratic to be a viable movement. By the time of the 1946 manifesto, his enthusiasm seemed to be waning, as he had already resumed painting in his usual style. It is possible that the broad rejection of this Renoiresque style led Magritte to undertake the most provocative stance in his career with his paintings of the Vache period.

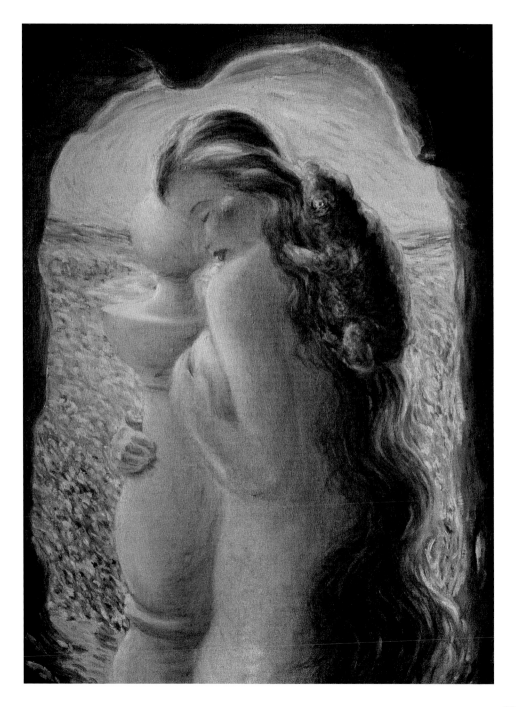

Ellipsis, 1948

Oil on canvas
50 × 73 cm
Royal Museums of Fine Arts of Belgium, Brussels

When an opportunity arose to hold his first solo exhibition in Paris, Magritte saw a chance to make mischief. Irked by the cool reception that his Renoiresque art had received in Paris and piqued that recognition of his art was so tardy (the artist was almost 50 years old), Magritte devised revenge. He would present not the art everyone was expecting, but instead a body of works that would be vulgar, crass, ugly, shoddy, lewd and vicious. This would be the Vache ("cow" or "beast") period, a unique body of about forty paintings, all made for this exhibition. Magritte enlisted Scutenaire to write an appropriately obtuse and slangy text for the catalogue.

The Vache paintings are erotic (the female nude), silly (a green rhinoceros on a pillar), weird (a tramp under a tartan sky) or madcap (heads eating each other). Unique to this period, Magritte used cartoonish caricatures and deployed metallic paint. The pictures are quickly painted but in *Ellipsis* we can see how exquisitely deft Magritte's touch had become. Notice how the constructed personage is crisply painted *alla prima* (wet-on-wet) and how boldly it stands out from its surroundings. The hands are accurate; the bulbous eyes are both comic and horrid. The staring eye in the hat reminds one of *The Portrait* (page 67). *Ellipsis* is unique in the Vache paintings in that it has a dark hilarity and a deeply unsettling tone. It is a masterpiece, and one cannot help but wonder what else Magritte might have gone on to produce in this manner.

It was not to be. The exhibition at Galerie Faubourg (from 11 May to 5 June) was a failure, just as Magritte had intended. Critics were chilly, Surrealist allies dismissive, visitors abusive; nothing sold. Magritte felt Éluard's compliments were half-hearted. The art languished in storage in Paris for years before being returned to the artist. The Vache explosion of defiance and bad taste was over and Magritte spent his last two decades working in his usual style. Although the paintings were ignored by most, their time would come. It is instructive to compare the Vache paintings to those of CoBrA (Asger Jorn, Karel Appel) and Picabia. The latter's audacious paintings – which combine kitsch and the absurd, erotica and ethnography – defy categorisation and parallel the Vache paintings. Since their inclusion in the *Westkunst* exhibition in Cologne (in 1981), Post-Modernists artists – in particular proponents of Bad Painting – have cited Magritte's Vache paintings as inspirational.

Personal Values, 1952

Oil on canvas
80 × 100 cm
San Francisco Museum of Modern Art

Personal Values is an example of disorientating alteration of scale. Magritte set himself new challenges throughout his career. Conjuring an entire world of stone was a task he tackled over the early 1950s. Making art that was ever more realistically executed was something that preoccupied him in the late 1950s and early 1960s. In order to elicit the greatest wonder, Magritte would paint in a way that would be even more precise and detailed. He took more care over consistency of light, shade, proportion and reflection. We can find this tendency in fantasy painters and illustrators of the late twentieth century and in the visual-effects designers in twenty-first century films.

Personal Values anticipates the Photorealism style that swept the USA and Europe in the 1960s. Still-life paintings featuring close-ups of common items, especially of glass and reflective material, was a staple of the Photorealists. Artists such as Audrey Flack assembled still-lifes of modern objects, photographed them and transferred the photographic designs via squaring or light projection on to canvases, where they could be outlined before being painted. Magritte used a slide projector for his 1938 "Life Line" lecture but he is not known to have used a projector in the painting process. An artist as capable and flexible as Magritte would not have needed light-projection devices to assist him to make the type of paintings he did.

Today, this painting is in the collection of the San Francisco Museum of Modern Art. When Iolas first saw this painting, he told the artist it was "unsaleable in the USA".

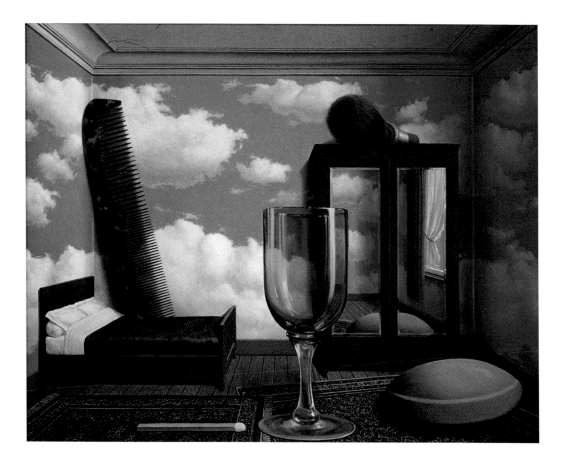

The Explanation, 1952

Oil on canvas
46 × 35 cm
Private collection

The visual similarity between wine bottles and carrots gives rise to a hybridisation of the two. While this is an iconic picture, it verges on the formulaic. We see a bottle, a carrot and a bottle-carrot. What connection do a bottle and carrot have, aside from a rudimentary resemblance in shape? *The Red Model* (1935) shows a pair of shoes hybridised with feet; it makes a meaningful analogy between feet and the garment that covers feet and presents a troubling invention. *The Red Model* is the more effective painting, but *The Explanation* is included here to show that Magritte's ideas could produce shallow – albeit attractive and memorable – art.

Magritte painted six oils and five gouaches of *The Explanation*. One of them is in an unfinished state. Something telling is that very few unfinished works by Magritte survive. These include his two last paintings, one almost finished and the other drawn in charcoal but not yet started. There are many preliminary sketches but no painting that is genuinely experimental or unresolved and there was little room for improvisation or chance in the painter's approach. Magritte overpainted or cut up paintings he considered failures. To begin a painting, he must have already settled any doubts about how to handle the execution.

One serious objection to Magritte is that – at least during his mature period – he seems to have rarely surprised himself when making pictures. Whilst the command of medium is admirable, we seem to be witnessing an artist proving to himself the correctness of his surmises. During Magritte's maturity, only the Vache paintings give the impression Magritte was uncertain of what the outcome of the painting process would be.

The Domain of Light, 1954

Oil on canvas
146 × 113.7 cm
Royal Museums of Fine Arts of Belgium, Brussels

"I have always been keenly interested in night and day, although I've never had a preference for one of the other. This intense personal interest in night and day is a feeling of admiration and amazement." Following the Magrittean principle of yoking opposites (day and night), *The Domain of Light* has proved one of the most beloved of the artist's inventions. Although this is (nominally) an impossible juxtaposition, it describes a real phenomenon; as such it is one of Magritte's pictures of eerie beauty rather than impossibility. An effect observable during early twilight is when the sky is comparatively bright and the ground becomes dark, with colours, especially reds and warm hues, muted to near monochrome. The juxtaposition of large dark areas against brightness has a perceptual effect that can induce a trance-like state of contemplation. If one stands still and concentrates on the undulated serrated outline of near-black foliage against the dazzling sky, it is possible to achieve a state of calmness. This is best done in front of the painting itself or a large reproduction. It occurs involuntarily when outside at dusk.

This statement from Magritte suggests he attained a state near to meditation when painting. "[Art] evokes the mystery without which the world would not exist, namely, the mystery that must not be mistaken for some kind of problem, difficult as that problem may be. I take care to paint only images that evoke the world's mystery. In order to do so, I have to be very wide awake, which means that I must totally cease identifying myself with ideas, emotions, sensations." Magritte found it beneficial to lose ego and self-awareness when working. Apparently, these quasi-transcendental techniques had no spiritual dimension for Magritte, who was an atheist.

One admirer of Magritte's art was American abstract painter Mark Rothko (1903–1970). He told David Sylvester, "Magritte is of course a case apart, but there is a certain quality in his work which I find in all the abstract paintings that I like. And I hope my painting has that quality." Rothko's large paintings require extended contemplation for a viewer to experience the interaction between blocks of colour with indistinct boundaries and the altering of retinal response to small fluctuations in light. The Rothko Chapel, Houston, housing paintings made for the purpose-built space, was funded by Magritte's benefactors, the de Menils.

Memory of a Voyage, 1955

Oil on canvas
162.2 × 130.2 cm
Museum of Modern Art, New York

Magritte wrote that his aim with this painting was to render "the description of a thought which brings together figures perceptible in the world in such a way as to evoke the mystery of the visible and the invisible", something he called "visible poetry".

This canvas is the culmination in a series of paintings entitled *Memory of a Voyage*. In them, the world is turned to stone. There are two canvases painted in 1950 and another in 1951 bearing the same title. This does not count the other paintings of Magritte's "stone age" of the early 1950s. *Memory of a Voyage* is the most complex of the group. It combines a figure (the poet Marcel Lecomte, according to Magritte's testimony), a lion (a motif first used in the 1930s) and a candle in a room made of stone. It is the most claustrophobic of these paintings.

Even the contents of a stone picture depict a world of stone through the medium of stone. The mountains behind the tower are vertiginous and rocky, offering no relief. It is a dazzling conceit. A further level is revealed when we consider the darkness of the room. Of course, it could be night-time, but even during daytime how could sunlight penetrate windows made of stone? The mind reels at the thought that perhaps even the sky and sun are made of stone. Such conclusions are beyond imagining.

The integrated nature and persuasiveness of Magritte's stone world are on a par with the elaborate alternative worlds invented by fantasy and science-fiction authors. Such conceptual thoroughness is rare in visual art.

The Listening Room, 1958

Oil on canvas
38 × 46 cm
Kunsthaus Zürich, gift of Walter Haefner, 1995

Apples perform many roles in Magritte's art: they float; they obscure faces; they acquire different colours; they are made of stone. Apples take on anthropomorphic qualities in the scenes where they wear masks. They change size, as they do here in *The Listening Room*. Many of Magritte's paintings are set in rooms, usually those of ordinary modern houses. The setting provides viewers with a sense of familiarity against which they can measure the unexpectedness of some incident or object. Situating a giant apple in a palace or aircraft hangar would be less powerful because the viewer would be distracted by the setting. This is a noticeable development in Magritte's approach. Consider *The Difficult Crossing*, *Entr'acte* and others, and how these paintings thrust us into strange worlds, buffeting us with multiple mysterious elements. The reduction in elements of incongruity was a deliberate act of refinement.

In response to demand, Magritte painted a number of versions of this composition, four in oils. A famous variant was *The Tomb of the Wrestlers* (1960), in which a giant rose fills a room. It was another painting that belonged to Torczyner.

Magritte's visual discoveries became popularised through exhibitions and publications, both in the art press and general periodicals and newspapers, in the post-war period. Popular culture – especially aided by pop music, book covers and the advertising world – took up Magritte's imagery and methods. Paul McCartney was a Magritte enthusiast and, inspired by paintings such as this, decided that The Beatles' company should be called Apple. Magritte was approached in 1967 about painting a portrait of Ringo Starr, but this did not come about. Years later, Linda McCartney bought her husband Magritte's easel, palette and spectacles from Magritte's widow.

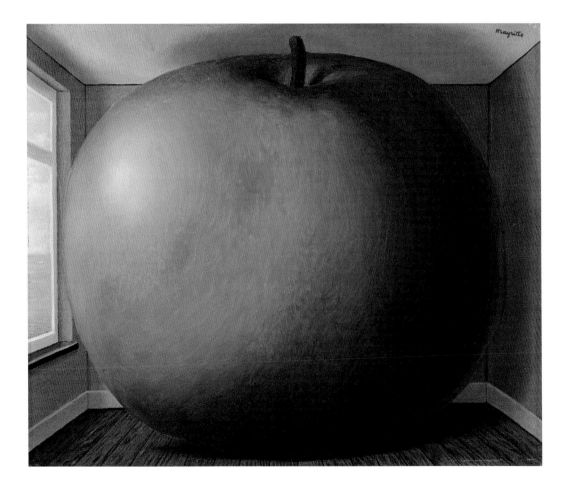

Castle in the Pyrenees, 1959

Oil on canvas
200.3 × 130.3 cm
The Israel Museum, Jerusalem

This picture displays a suspension of the law of gravity, permitting the formidable spectacle of a floating boulder surmounted by a castle. The seascape is adapted from *The Wave*, a painting by Vartan Makhokhian (1869–1937), an Armenian marine painter. A postcard of Makhokhian's painting, squared up for transcription, was in Magritte's possession.

We have an exchange of letters documenting the genesis of this painting. Torczyner commissioned Magrite to paint a picture to a specific size, for his law office on Fifth Avenue, New York. In a March 1959 letter, Magritte offered Torczyner three compositions, of which Torczyner chose the final design. Magritte described it as "the stone in the air crowned with an old castle with a few trees around it, the view will be in eternal daylight, blue sky and clouds above a restless Northern sea." One initial sketch included a balustrade, but Magritte rejected this element. "It appears that without the balustrade, the waves of the sea are more visible, the stone more 'in the air', and one has the sensation of seeing things from the beach, and not from the confines of an interior? – With the balustrade, things are a bit 'closed in', they seem to be confined – whereas for this picture, the space shouldn't give the impression of being in any way restricted." The trees beside the castle, along with the balustrade, were eliminated from the composition before Magritte began painting.

By 20 April 1959, Magritte announced that the painting was nearly complete and would be shipped to New York the following month. Torczyner owned this painting until 1985, when he donated it to the Israel Museum.

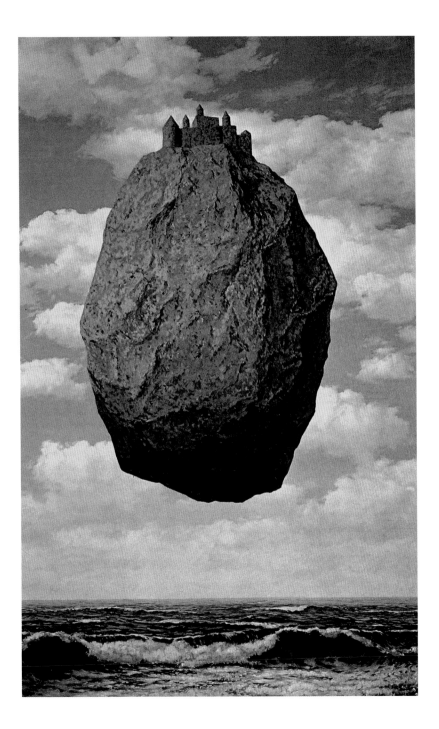

Blood Will Tell, 1959

Oil on canvas
116 × 89 cm
Museum Moderner Kunst, Stiftung Ludwig, Vienna

Magritte made two very brief comments about this composition. "The sphere and
the house suggest enigmatic measurements to the tree. Curtains hide what is no
earthly use." "The words dictated by our blood sometimes seem mysterious to
us. Here it seems we are ordered to open up magic niches in the trees." Magritte
declined to interpret his art and was unreceptive to others doing so. Realising
that the power of an enigmatic image was undone by a critique which rationalised
a picture, the artist refused to open any line of explanation. Other than the title
and rare comments of an allusive nature, Magritte eschewed the verbal. In private
letters (notably those to Gablik, Torczyner and writer André Bosmans), Magritte
could be more forthcoming. He tended to discuss how a painting came into
existence and mention rejected alternative solutions, without outlining what his
interpretation of the final picture might be. Intellectualising his art would be, as
Magritte considered it, to fail to understand art's purpose.
The title *Blood Will Tell* suggests that a person's inner nature will eventually find
its way of manifesting itself. The painting shows a tree revealing its previously
concealed truth. The image of the tree with compartments was included in the
massive mural *The Enchanted Domain* (1953). David Sylvester, a leading Magritte
scholar, suggests that opening doors of the tree may have been derived from
an encyclopaedia illustration of the harvesting of cork bark. A number of other
motifs came from the same book, including the shipwreck in *The Difficult Crossing*
(page 47).

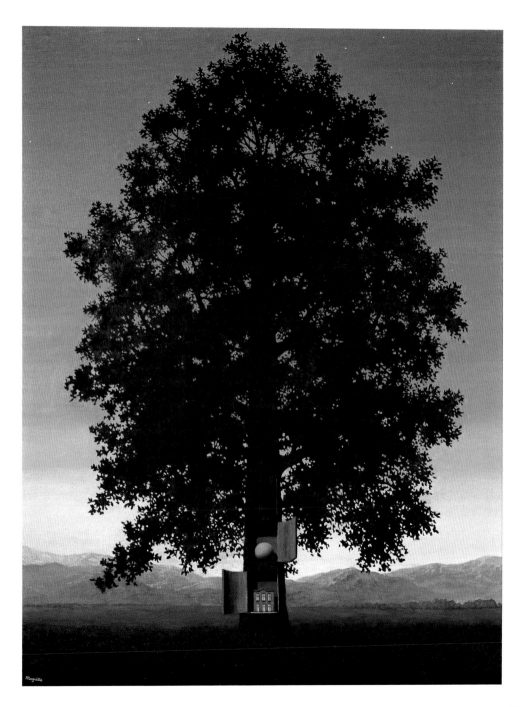

The Horns of Desire, 1960

Oil on canvas
116 × 89 cm
Private collection

One of the most striking aspects of Magritte's universe is the absence of humanity. There are figures, certainly. However, most of women are nudes-cum-goddesses and the men are usually examples of *l'homme moyen* – the everyman so lacking in individual qualities that he becomes a reproducible cipher. Magritte's women are transcendentally beautiful paragons of ineluctable magic and eternal nature; his men are inscrutable and passive, tamed and neutered by civilisation. Their suits and hats are markers of their anonymity.

This is one reason why Magritte's commissioned portraits are unsuccessful. One recognises that these Belgian businessmen and American high-society hostesses are interlopers in a world that is centred upon primal values and eternal elements. In *The Horns of Desire* we encounter the ultimate expression of Magritte's aversion to dwelling upon humanity as a subject for art. In this painting, two women have not so much been dematerialised or rendered invisible; rather, they have been replaced by their garments. (Although, as an avid fan of mysterious cinema, Magritte would have been aware of the acclaimed 1933 film adaptation of H. G. Wells's *The Invisible Man*.) This painting was created at a point in the Cold War when there was much speculation on the impact of the neutron bomb, a weapon then being developed which was popularly – and incorrectly – supposed to destroy people without destroying non-living matter.

There is merit in considering Magritte's art as parallel to Existentialism in its refutation of the secure universe found in the heroic narratives of religion and nation. Where Magritte's outlook differs from Existentialism is in its rather bleak scepticism regarding the centrality of humanity. Existentialists believed meaning resided in the way in which a person could find purpose in an indifferent universe through willed action and communication; in pictures such as *The Horns of Desire*, we see the reverse: a world stripped of people. We find more mordant pessimism regarding humanity in the series entitled *Perspective* (starting in 1949, ending 1951). These recreate classic paintings of art history, with protagonists in coffins (page 35).

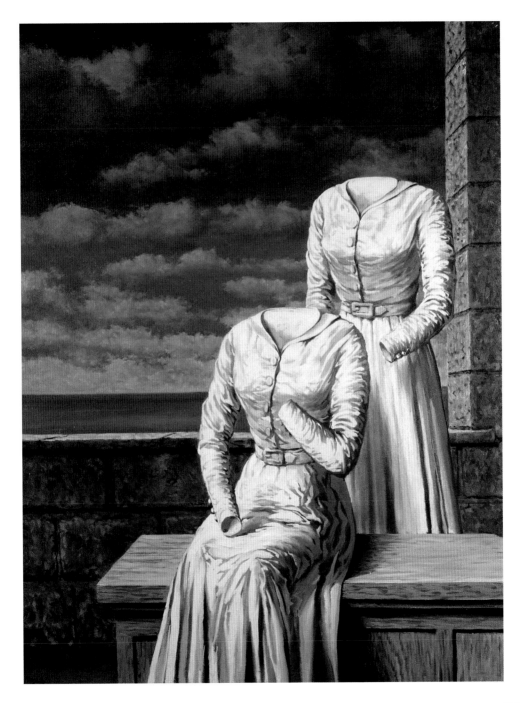

Heartstring, 1960

Oil on canvas
114 × 146 cm
Private collection, New York

"The forbidden but not inaccessible skies, all the elements of the picture presented
to our gaze rediscover their essential existence in the idea which positions them like
counters in a vital game. The cloud which caresses a glass more than the glass holds
it back, that the nearness of the mountains liberates more than it confines, leads,
with the tender delicacy of a loving hand, to an ultimate obviousness." So wrote
Scutenaire of *Heartstring*.

One of the reasons Magritte's art is so cherished is the sense of continuity in the
settings. If one views a body of his paintings one gains familiarity with the places
Magritte inhabits mentally: the Belgian suburb, the balustrade overlooking a night
sky or mountain view, the meadow with distant woods, the beach. This valley plain in
a temperate climate with stony mountains can be found in *Blood Will Tell* (page 99),
among other compositions. In 1963, Magritte created two other paintings with this
view, one depicting a gigantic levitating boulder, another with an equally large
apple made of stone. Due to congruence of style, imagery and settings, one could
get the impression that Magritte's paintings depict a single alternate world. This is
not something that Magritte ever discussed but his body of work does allow for that
interpretation. Certainly, the titling of the 1953 mural – which amounted to a summary
survey of inventions in a single space – *The Enchanted Domain* does reinforce such
an interpretation.

On the question of interpretation, the artist was vexed to hear viewers compare the
combination of champagne glass and cloud to the image of an atomic mushroom
cloud. Whether or not such a topical image did provide unconscious spur for this
invention, Magritte thought such links were facile and diminished the essential task
of art: namely to startle a person into appreciating the poetry of the visible world.

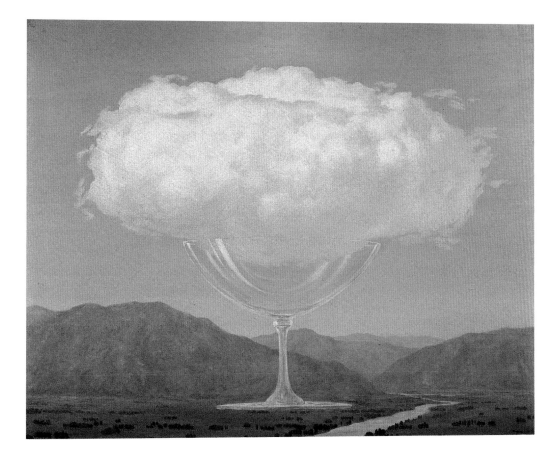

Towards Pleasure, 1962

Oil on canvas
46 × 55 cm
Private collection

There is nothing in this painting that is impossible or incredible. The atmosphere is haunting but not uncanny. In Magritte's corpus, we have encountered the curtain, figure, wood and night sky before. In this painting, we are invited not to confront the amazing but to contemplate the eerie beauty that does not defy logic. Magritte once described in a letter a vision he wished to paint: a skeleton plucking a rose in a midnight garden. It was a subject he never painted, probably because it was too close to the imagery of his rival Delvaux.

Although Magritte's art is considered Surrealist in character, it is also an extension of the Romantic tradition. In this painting, Magritte's man echoes the *Rückenfiguren* (figures seen from the rear) innovated by Caspar David Friedrich (1774–1840). Friedrich's lone wanderers show scale and present man in the face of untamed nature. Most importantly, these painted figures act as spectator surrogates, allowing us to imagine ourselves inside the pictorial space of the painting. Presented with an anonymous figure, we imagine ourselves in his or her situation, by extension experiencing that figure's awe in the face of nature so dramatic, beautiful, appalling or mysterious it acquires the attributes of the sublime. Sublimity – in Romantic terms – is when an experience is beyond human comprehension and transports the subject through overwhelming emotion.

The nocturne was a specialism of Johan Christian Dahl (1788–1857), a Norwegian Romantic painter who was a colleague and friend of Friedrich's. Dahl was acclaimed for his nocturnal views of Dresden with the full moon lighting tattered clouds. Magritte would have known Friedrich and at least some of the imitators of Dahl. *Towards Pleasure* is evidence of Magritte's poetic affinity for northern European Romanticism, an aspect that has been largely overlooked by critics.

The Great Family, 1963

Oil on canvas
100 × 81 cm
Utsunomiya Museum of Art, Tochigi

When questioned about his ideas, Magritte replied "I have nothing to express! I simply search for images and invent and invent. The idea doesn't matter to me: only the image counts, the inexplicable and mysterious image, since all is mystery in our life. I paint the beyond, alive or dead." The idea is the apparition of a flying dove of clement weather impressing itself into the stormy sea view.

The dove was a motif to which Magritte returned many times. He and Georgette kept doves in the 1930s. In Magritte's pictures the dove embodies flight, movement, freedom and independence. The frisson of contradictory states in conjunction, combined with the dynamism of the bird's outline, gives the painting some tension. A painting similar to this was used as the logo for Sabena, the Belgian state airline.

In his final paintings, Magritte took pleasure in creating visions that were delicately painted presentations addressing the biggest of subjects: melancholy for the unattainable, the beauty of woman, wonder at the material world, the absolute extinction of death. In the very best of them, Magritte attained a majesty unmatched by any artist since the advent of Modernism. We can contemplate them at length without ever resolving their contradictions and never being frustrated at being thwarted, something that is not true for most of his earlier pictures, which intend to provoke or perturb.

The Great Family is one of the late Magrittes that act as Buddhist *koans*, unresolvable riddles such as "the gateless gate" and "the sound of one hand clapping", which free the subject of his or her instinct to solve problems through deduction and reason, instead prompting the subject to meditate deeply and discover a concealed inner truth.

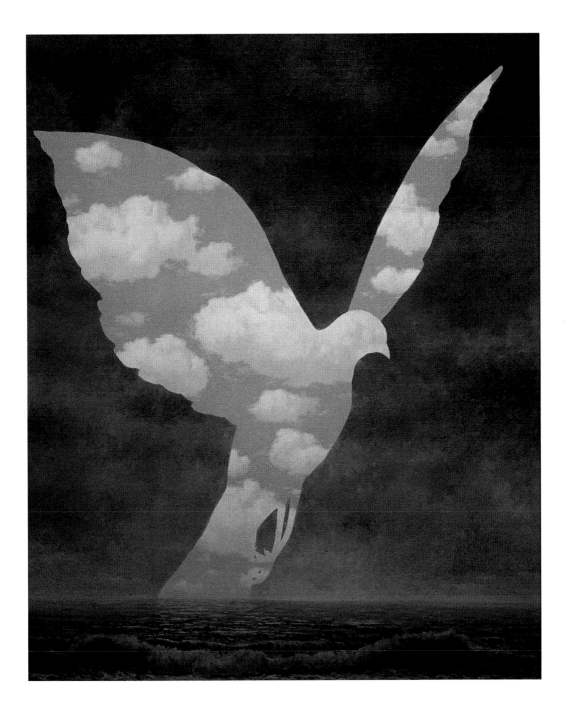

The Friend of Order, 1964

Oil on canvas
100 × 81 cm
Private collection, France

The Friend of Order is one of a series of late variations of *l'homme moyen* facing the viewer, with or without a balustrade behind him, against a simple backdrop. Sometimes he is accompanied by a *grelot* (bell), sometimes by an echo of himself. Frequently, he has been emptied out and reduced to a shape.

Some writers have stated Magritte's art did not evolve. This is untrue. There is considerable distance emotionally, technically, conceptually as well as aesthetically between the paintings of the 1920s and the 1960s. This development is somewhat obscured by Magritte's practice of making versions of popular compositions. Nonetheless, observation shows how Magritte's art became less agitated and more reflective as he aged. In his early period, Magritte's exploration of the compelling fascination for violence, sex and the macabre, and then in his late period his embrace of the serene glories and sublime drama of landscape, exemplify both facets of Romanticism, namely the investigation of primal drives of Man and the celebration of the transcendental beauty of Nature.

From *The Empty Mask* (page 57) onwards, Magritte distilled the essence of materials and places. In his last paintings, the artist used the outline of the man in the bowler hat as a template. Any potential that the figure might have had as a character or individual is now wholly set aside as he is filled by parts of the universe: night sky, sea, curtains, leaves, countryside at twilight. He is absorbed into the cosmos, as if he were a person leaving his earthly frame behind at the point of death. These paintings are the elderly Magritte's reflections upon mortality. When he painted *The Friend of Order*, his artistic temperament was closer to that of a Romantic than a Surrealist. Subversion falls away as René Magritte, in his final years, sought profundity, beauty and wonder in the illimitable mystery of the world.

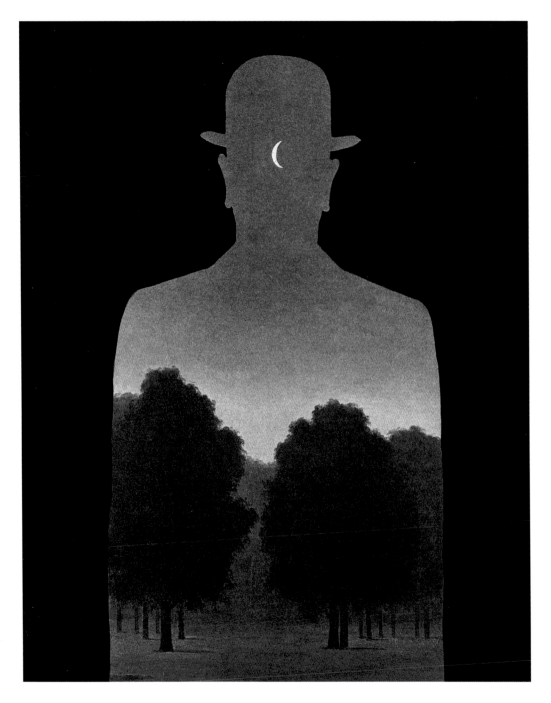

FURTHER READING

Canonne, Xavier (ed.), *Magritte: Life Line*, Milan, 2018

Danchev, Alex, *Magritte: A Life*, New York/London, 2021

Draguet, Michel, *Magritte & Dalí*, Brussels, 2018

Gablik, Suzi, *Magritte*, London, 1973

Hammacher, Abraham Marie, *René Magritte*, New York, 1973

Lipinski, Lisa, *René Magritte and the Art of Thinking*, London, 2019

Magritte, René, *Écrits complets*, Paris, 2009

Magritte, René, *Selected Writings*, Surrey, 2016

Magritte, René and Torczyner, Harry, *Letters Between Friends*, New York, 1994

Meuris, Jacques, *René Magritte*, London, 1988

Noël, Bernard, *René Magritte*, Paris, 1977

Roegiers, Patrick, *Magritte and Photography*, Brussels, 2005

Schlicht, Esther, and Hollein, Max (eds.), *René Magritte, 1948. La Période Vache*, Brussels, 2009

Silvano, Levy, *Decoding Magritte*, Bristol, 2015

Sylvester, David, and Whitfield, Sarah (eds.), *René Magritte: Catalogue Raisonné, Vols. I-V*, Houston/Brussels, 1992–97

Whitfield, Sarah (ed.), *René Magritte: Newly Discovered Works. Catalogue Raisonné VI*, Houston/Brussels, 2012

PHOTO CREDITS